IMAGES
of America

The SAVANNAH COLLEGE of ART and DESIGN
Restoration of an
Architectural Heritage

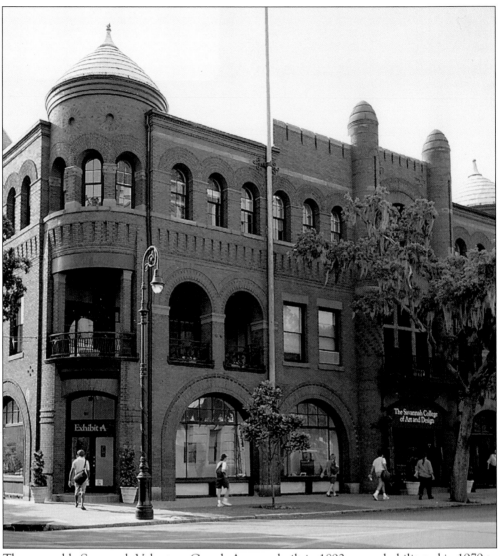

The venerable Savannah Volunteer Guards Armory, built in 1892, was rehabilitated in 1979 to serve as the flagship building for the Savannah College of Art and Design. (Courtesy of SCAD Campus Photography.)

(*on the cover*) This 1946 view of the Savannah Volunteer Guards Armory shows its mid-century role as a vital neighborhood anchor building before it later abandonment. (Courtesy of the Georgia Historical Society, Cordray-Foltz Collection.)

IMAGES
of America

The SAVANNAH COLLEGE of ART *and* DESIGN
Restoration of an Architectural Heritage

Connie Capozzola Pinkerton,
Maureen Burke, Ph.D.,
and the Historic Preservation Department of the
Savannah College of Art and Design

ARCADIA
PUBLISHING

Published by Arcadia Publishing
Charleston, South Carolina

Printed in the United States of America

Library of Congress Catalog Card Number: 200411719

For all general information contact Arcadia Publishing at:
Telephone 843-853-2070
Fax 843-853-0044
E-mail sales@arcadiapublishing.com
For customer service and orders:
Toll-Free 1-888-313-2665

Visit us on the Internet at www.arcadiapublishing.com

This book is dedicated to May L. Poetter and Paul E. Poetter, co-founders of the Savannah College of Art and Design. To transform a bright educational vision that is an insubstantial dream and a prayer to a brick-and-mortar reality requires commitment, energy, perseverance, humor, and hope. The Savannah vision also required the additional perception to see in abandoned and ruined buildings the elegance, majesty, and charm that could be restored to serve as a unique campus. The college's current prominence could never have evolved without the initial dedication and continuing support of these special people.

The college's flagship building was the former Savannah Volunteer Guards Armory, which today bears the name Poetter Hall to honor college co-founders May and Paul Poetter, who spent many years working on and working in the building as the fledgling college took wing. (Courtesy of SCAD Campus Photography.)

CONTENTS

Acknowledgments 6

Introduction: The Urban Campus: Revitalizing Historic Sites and

 Spaces in a Colonial Port City 7

1. College Flagship on a Savannah Square: William G.

 Preston's Savannah Volunteer Guards Armory 11

2. The Central of Georgia Railroad Complex: A Victorian

 Landmark in Brick and Brownstone 27

3. A Quartet of Turn-of-the-century Schools: Savannah

 Academic Traditions Continue 51

4. Monuments of Civic Society: Banks and Jail, Church

 and Charity 65

5. An American Vernacular of Industry and Commerce:

 From Main Street and the Carriage Trade to the

 Automobile Era 81

6. From Gracious Homes to Academic Elegance:

 Reinterpreting Private Spaces 101

Appendix: Profiles of Prominent 19th-century Architects of

 Savannah College of Art and Design Buildings 125

Suggested Reading 127

Index 128

ACKNOWLEDGMENTS

This book has been made possible through the valuable contributions of numerous people in the college community, including many faculty, students, and alumni of the historic preservation department as well as members of the SCAD Campus Photography and Campus Printing departments. A special debt is owed to Robert Dickensheets, senior preservationist at the college, for his extensive support and assistance, as well as to Timothy Hoal of the Newton Center. The staff members of the Georgia Historical Society, the Lane Library of Armstrong Atlantic State University, the Georgia State Archives, and the Boston Public Library have provided much professional support. A great deal of the recent research on the campus buildings has been made possible by the generosity of the Getty Trust through its Campus Heritage Preservation Planning initiative. The interns, faculty, architects, and other students who participated in the project deserve particular recognition.

The college's efforts at preservation have been supported across the years by many local groups and individuals, including the Historic Savannah Foundation, the Metropolitan Planning Commission, the Savannah Development and Renewal Authority, the city preservation officer, Leopold and Emma Adler, and the late W.W. Law, as well as by state and national groups including the Georgia Department of Natural Resources, Historic Preservation Division; the Georgia Trust for Historic Preservation; the National Park Service; and the National Trust for Historic Preservation.

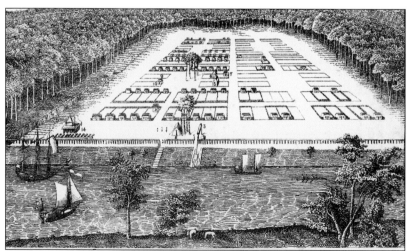

The colony's founder, Gen. James Edward Oglethorpe, designed the city plan of Savannah in 1733. The city's squares and grid layout from the oldest plan in North America still define the historic heart of the city. This 1734 map was commissioned from Peter Gordon to show the Georgia Trustees in England the fledgling colony. It is the earliest view of Savannah. (Courtesy of the Georgia Historical Society.)

INTRODUCTION

The Urban Campus: Revitalizing Historic Sites and Spaces in a Colonial Port City

"Fine art is always the product of an interaction of human beings with their environment. Architecture is a notable instance of the reciprocity of the results of this interaction . . . but human life itself is also made different, and this in ways far beyond the intent or capacity of forethought of those who constructed the buildings. The reshaping of subsequent experience by architectural works is more direct and more extensive than in the case of any other art save perhaps literature. They not only influence the future, but they record and convey the past."

–John Dewey

Savannah's fascinating history extends back to 1733, the year in which Gen. James Oglethorpe founded this captivating capital of Georgia, one of the original 13 colonies. Visionary, pragmatic, and possessed of sure aesthetic instincts, the then 37-year-old Oglethorpe designed an ordered, geometric grid of tree-filled squares framed by rhythmic strips of streets, many of which still exist. They form the oldest city plan of North America and, centered around fountains or stone and bronze monuments, the squares have become outdoor sculpture gardens shaded by magnolias and by live oaks festooned with Spanish moss. During the 19th century, Savannah was often dubbed "Forest City." People and natural elements intermingle in these semi-tropical oases, vibrant in spring with abundant azaleas.

A languid elegance redolent of earlier centuries still haunts the city, for around the nucleus of picturesque squares, a wonderful architecture has survived the vicissitudes of time and of the Civil War. More than 1,000 significant buildings from the 19th and even the 18th century densely embellish the 2.5-square mile Historic Landmark District, designated by the National Park Service as one of the nation's largest historic districts. The cityscape creates a physical dialogue between the past and the present; its distinct architectural sensibility becomes an ordered urban fabric.

This sense of place and heritage was threatened in the latter half of the 20th century as economic downturns and ill-advised urban development contributed to the loss of several landmark buildings in the historic heart of the city, among them the City Market in 1954, the Beaux-Arts Union Station in 1963, and the Romanesque revival DeSoto Hotel in 1966. These losses acted as catalysts for a remarkable preservation movement in Savannah that began in the 1950s with the creation of the Historic Savannah Foundation. Restoration efforts focused on individual structures such as the Davenport House, the Owens-Thomas House, and the Juliette Gordon Low Birthplace, and on streetscapes and neighborhoods such as the Trustees Garden area and the Beach Institute neighborhood, where hundreds of structures were saved.

One of the strongest champions for historic preservation has been the Savannah College of Art and Design. In March 1979, when the college founders acquired the 1892 Savannah Volunteer Guards Armory to serve as the college's anchor building, they were dealing with a grand ruin, a three-story red brick edifice designed by Boston architect William Gibbons Preston

on Madison Square at Bull Street. The massive armory had deteriorated past the point where its original owners felt that it could be saved: there was no heat, the plumbing had to be replaced, and the majority of the building lacked electricity, while the roof and walls needed extensive work.

Considerable rehabilitation efforts preserved the original floor plan and decorative detail while modernizing the interior to serve as classroom, studio, and office spaces. The college opened its doors in September 1979 and received an award from the Historic Savannah Foundation the following year for its exemplary renovation of the armory, then called Preston Hall after its architect and later Poetter Hall after two of the founders. This began a practice the college has continued for the past 25 years, acquiring historically significant abandoned buildings in disrepair and bringing them to new life through adaptive re-use. With the city itself acting as a living laboratory, the building arts were among the earliest majors offered at the college, with degree programs in historic preservation, architecture, interior design, and, later, architectural history.

More than 60 historic buildings serving some 6,600 students as a unique urban campus have now been rehabilitated, and preservation efforts are ongoing. The structures represent a rich diversity of historic styles and origins from classical revival through the picturesque range of the Victorian era and on past the Art Deco period. Many were abandoned neighborhood anchors such as school buildings, stores, a power station, a church, banks, a jail, railroad warehouses, residences, and office buildings.

Located in four distinct historic districts—the 2.5-square-mile Savannah National Historic Landmark District, the adjacent Central of Georgia Railroad Savannah Shops and Terminal Facilities Landmark District, the Savannah Victorian District, and the Thomas Square Trolley Historic District—the college buildings and the positive role their preservation has played in safeguarding Savannah's architectural heritage have been acknowledged by national awards from the National Trust for Historic Preservation, the International Art Deco Society, the American Institute of Architects, the International Downtown Association, the National Main Street Center, and the Victorian Society in America, as well as various awards from the Historic Savannah Foundation, the Georgia Cities Foundation, and the Georgia Trust for Historic Preservation.

Serving as a national model for adaptive re-use, the restored buildings at the Savannah College of Art and Design offer a rich vision of Savannah's past and multiform architectural energies as expressed in the built environment. At the height of Savannah's prosperity in 1888, one writer described the city for *Harper's New Monthly Magazine*, concluding with the Telfair Academy. He found only one area for civic improvement: "The creation of an art school is the next step in this enterprise. The foundation has been laid in a comprehensive collection of the best art achievements of the world for appreciation and study. This institution, properly managed, developed, and utilized, must make Savannah the art centre of the South."

Fulfilling this prophecy, and in the process bringing deserted buildings to a creative new life, the Savannah College of Art and Design merges architecture and art with a strong sense of Savannah's architectural legacy.

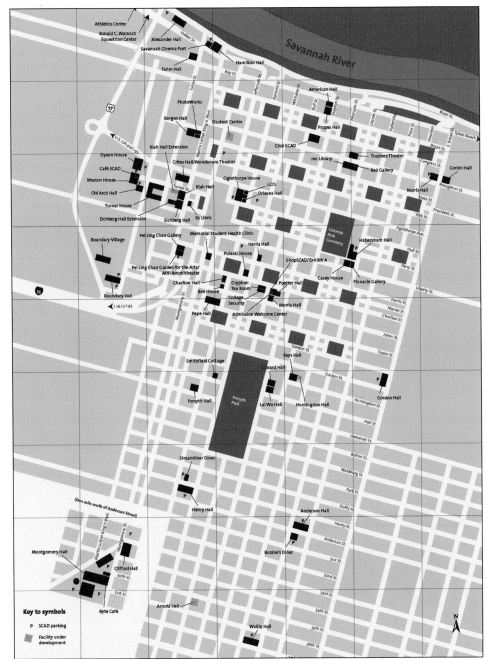

The Savannah College of Art and Design occupies more than 60 historic buildings, which serve some 6,600 students as academic, studio, and residential spaces. The college also utilizes its rehabilitated buildings for exhibition and performance spaces and for administrative and auxiliary functions. The majority of the campus structures are located in Savannah's 2.5-square-mile National Historic Landmark District, but others are found in the adjacent Central of Georgia Railroad Savannah Shops and Terminal Facilities Landmark District, the Savannah Victorian District, and the Thomas Square Trolley Historic District. (Courtesy of SCAD Campus Printing.)

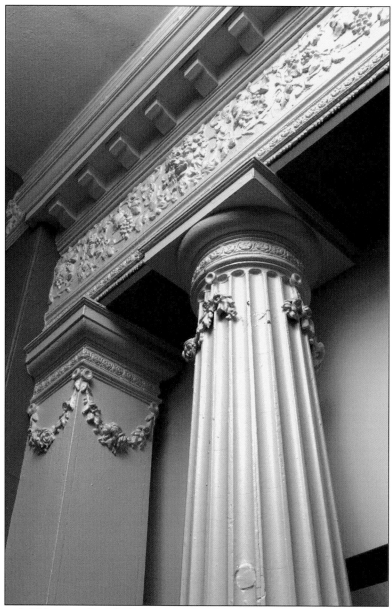

The Savannah Volunteer Guards Armory was lavishly decorated, particularly in the clubhouse portion found on the western Bull Street side. This detail suggests the original splendid appearance of the armory, which had suffered the vicissitudes of a 1928 fire and of time. The structure was in a much deteriorated condition when acquired by the Savannah College of Art and Design in 1979. Its adaptive re-use was honored by the Historic Savannah Foundation's Excellence in Restoration Award in 1980. The oblique view of two of the interior western columns of the clubhouse's lounging room provides a glimpse of the building's wealth of ornate detail. These elegant columns—one fluted and one a simple pillar—are united by their floral swags. More relief floral decoration is found in the frieze above, with dentils marching along the cornice section. These cast plaster and carved wood elements mask a large riveted iron girder and interior iron columns. (Courtesy of SCAD Campus Photography.)

One

College Flagship on a Savannah Square

William G. Preston's Savannah Volunteer Guards Armory

The Savannah Volunteer Guards Armory (now Poetter Hall) was designed in 1892 by Boston architect William Gibbons Preston and built by James G. Cornell. It is the largest and most complete historic military building in the South. In 1979, it was rehabilitated to serve as the flagship building of the Savannah College of Art and Design. Its Richardsonian Romanesque style is richly detailed with turrets, arches, wrought iron, ornamental plaster, crenellations, terra cotta, and fine red brick masonry. (Courtesy of SCAD Campus Photography.)

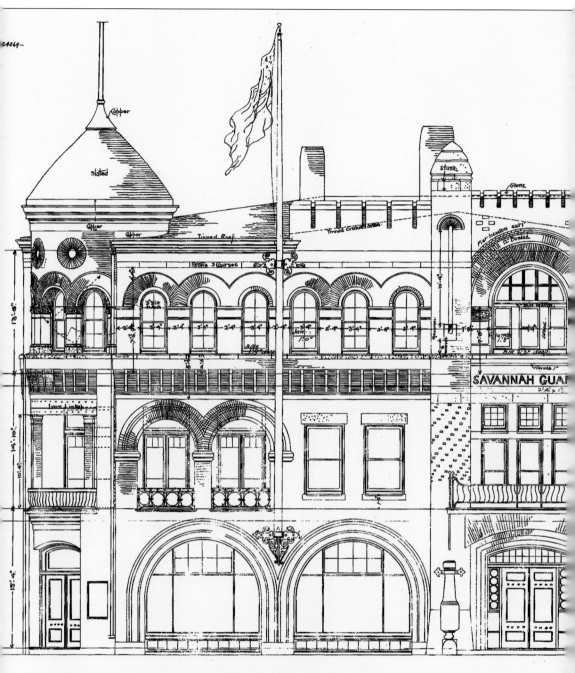

·Bull· St· Elevation·
·Savannah· Guards ·Armory·
·Savannah; Ga·

Scale ⅛ in ·1 ft·

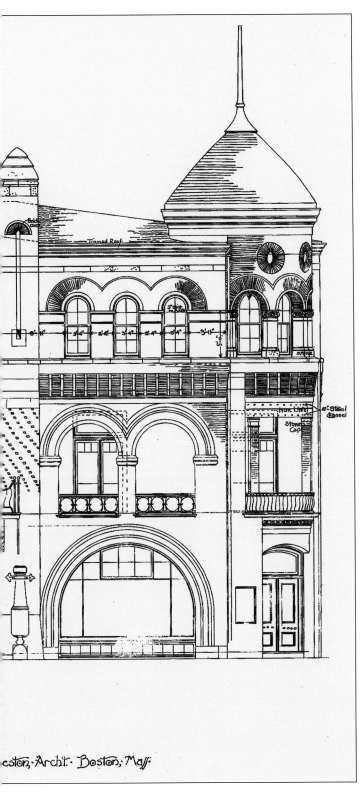

Poetter Hall's choice location at 340–344 Bull Street alongside Madison Square was the former site of the Savannah Female Orphan Asylum when the Volunteer Guards closed on the three-lot property in November 1890. They selected as their architect Bostonian William Gibbons Preston. Work began in February 1892, with the plan to attach a drill hall/armory behind the existing structure. A last-minute decision was made to demolish the previous building and replace it with a single building containing a larger drill hall and more spacious company rooms, a bowling alley/rifle range on Charlton Street, and storefront space on Bull Street to create an effect of "magnificence," as Preston proclaimed. He visited the site in May, making additional alterations. The three-story plan seen here is Preston's design as it was actually implemented. (Courtesy of the Boston Public Library, Fine Arts Department.)

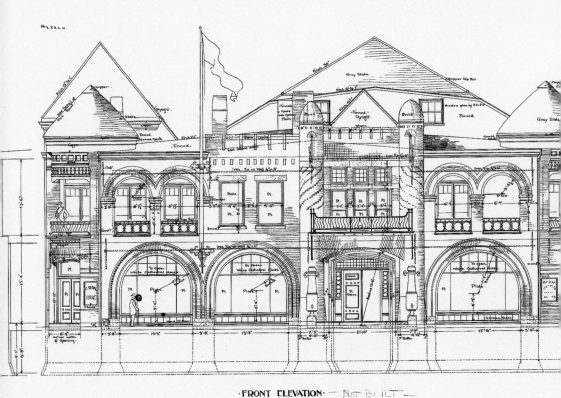

· FRONT ELEVATION · — NOT BUILT —
· SAVANNAH GUARDS' ARMORY ·
· W·G·PRESTON ARCH'T · · SCALE ½ IN·1 FT·

Hogan's Fire of April 1889 destroyed the previous armory at Whitaker and President Streets, which had been erected in 1885 by New York architect J.A. Wood. The replacement by Preston was initially planned in 1892 as a two-story building. After the first floor was built, the Guards decided to add a third floor in August 1892. Total costs for land and construction exceeded $100,000. This plan reveals Preston's original two-story concept. On either side of the portal in both plans may be seen 24-pound cannon mounted vertically like columns. They were retrieved from the earlier building, where they had been discovered during the excavation for the armory's foundation built on the site of the old City Arsenal. They are believed to be part of the armament of the USS *Constitution*, "Old Iron Sides," and are thought to be of French origin. (Courtesy of the Boston Public Library, Fine Arts Department.)

William Gibbons Preston (1842–1910) was a distinguished architect from Boston who studied at Harvard and later at the Ecôle des Beaux-Arts in Paris. He was originally invited to Savannah by George Baldwin, the first president of the Savannah Electric and Power Company, who had met Preston at the Massachusetts Institute of Technology and secured the commission of the Savannah courthouse for him. (Reproduced from *Men of Massachusetts*, Boston: Boston Press Club, 1903. Courtesy of the Boston Public Library, Fine Arts Department.)

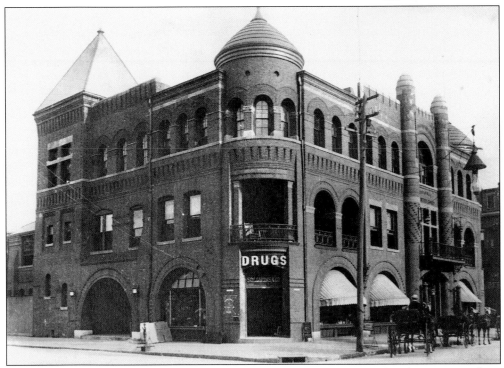

A corner drugstore is visible in this turn-of-the-century photograph of Poetter Hall in horse-and-buggy days with an early electric streetlight. This was Solomon's Drugstore, a storefront property incorporated into the original armory plan. Abraham A. Solomon and his brothers founded Solomon's Drug Company around 1850. (Reproduced from Charles Edgeworth Jones, *Art Work of Savannah and Augusta*, Chicago: Gravure Illustration Co., 1903. Courtesy of the Georgia Historical Society.)

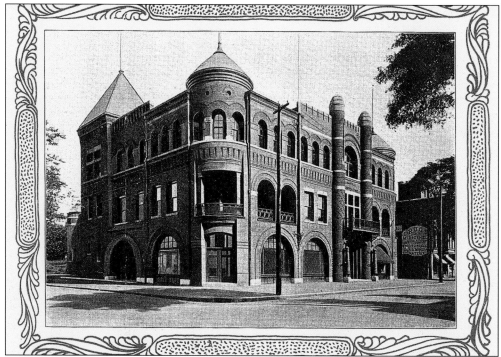

The new Savannah Guards Armory appears in this early photograph from an 1899 Central of Georgia Railroad Company guide to Savannah. The massive structure rises three stories with the clubhouse entrance found on Bull Street and the drill hall entrance on Charlton Street. Built of pressed red brick with red mortar, brownstone, wrought iron, terra cotta, and wood, Poetter Hall occupies 36,248 square feet. (Courtesy of the Newton Center, SCAD.)

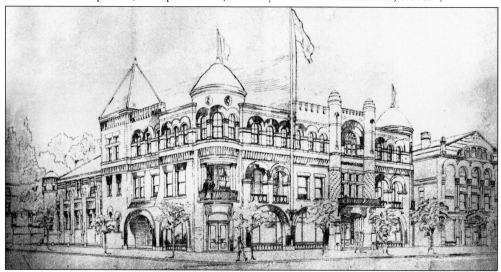

This 1892 drawing of the Savannah Volunteer Guards Armory shows its original appearance and is probably by Preston. It graced the cover of the January 14, 1893 issue of *American Architect and Building News*, testifying to the national importance of the armory's design. (Reproduced from Charles H. Olmstead, *Artwork of Savannah*, Chicago: W.H. Parish, 1893. Courtesy of the Georgia Historical Society.)

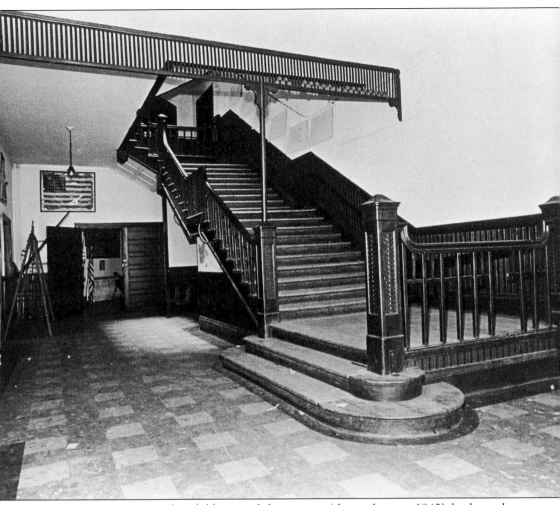

The Bull Street atrium to the clubhouse of the armory (shown here c. 1940) leads to the stately eight-foot-wide staircase and the upper pine balustrade with the carved newel post and turned balusters. At the back of the hallway may be seen military memorabilia. The Savannah Volunteer Guards were the oldest infantry company in Georgia, founded in 1802. The armory was also used for social occasions. For an assembly ball in 1900, "the hall was decorated for the occasion with great success. The windows were draped with pink and white hangings, while the general outlines were broken with tall palms . . . a soft light was spread over everything from the deep rose shades covering the electric globes . . . a beautiful supper was served at midnight in the company rooms downstairs." (Courtesy of SCAD Campus Photography.)

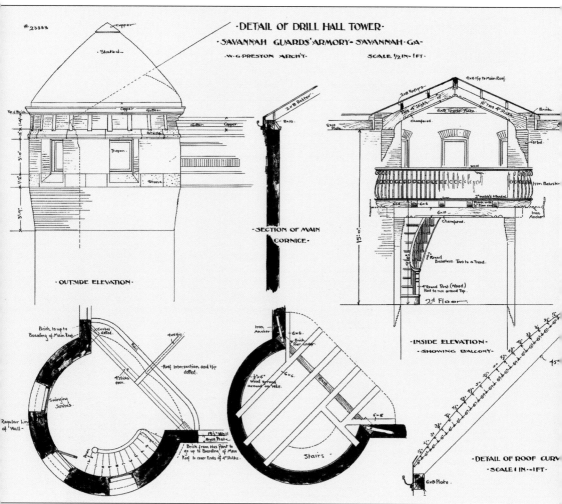

·DETAIL OF DRILL HALL TOWER·
·SAVANNAH GUARDS' ARMORY· SAVANNAH·GA·
·W·G·PRESTON ARCH'T· SCALE 1/2 IN·1FT·

·OUTSIDE ELEVATION·

·SECTION OF MAIN CORNICE·

·INSIDE ELEVATION·
·SHOWING BALCONY·

2d Floor

·DETAIL OF ROOF CURV·
·SCALE 1 IN·1FT·

Preston created almost 40 sheets of meticulous plans as part of the armory project, including various interior details. At the back of the drill room area in the northeast corner tower is a small, wrought-iron interior balcony reached by an iron spiral stairway. It overlooked the original drill room, a 60- by 90-foot space also used for entertainment. Chamfered beams may be seen supporting the balcony and the drill room roof. The wrought-iron balusters are sweeping with a scrolled detail at the top, similar to those found on the exterior balcony. The turret is sheathed in gray slate with a copper cap. By October 1892, the second story had been completed, and it was noted that "hard burned brick is used in the building, the iron girders are thirty inches in width and all the timbers and cross pieces are of a large size best timber." In November 1892, work was temporarily suspended because of a labor strike in Newark, where the iron girders were being manufactured. (Courtesy of the Boston Public Library, Fine Arts Department.)

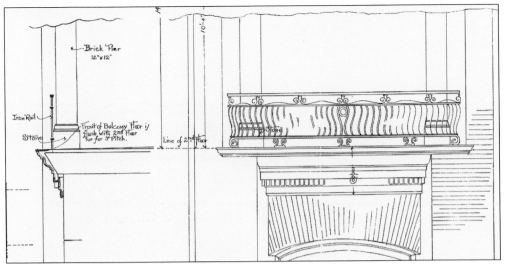

Preston's plan for the exterior corner balcony on the second floor also illustrates his attention to materials and craftsmanship. This rounded corner overlooks the important intersection of Bull and Charlton Streets, commanding a view of Madison Square. Many civic events, parades, and military reviews took place along this route. (Courtesy of the Boston Public Library, Fine Arts Department.)

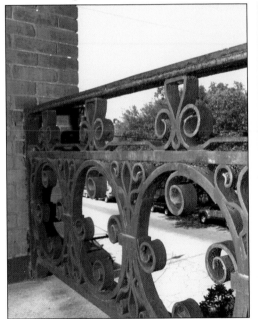
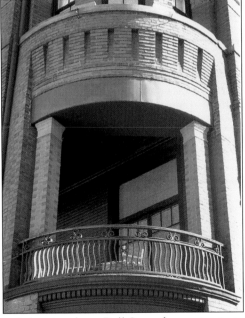

(*above, left*) This detail of one of the wrought-iron balconies above Bull Street has an intricate repeated scroll pattern of heavy gauge iron with a circular motif in the lower section. (Courtesy of SCAD Campus Photography.)

(*above, right*) The corner balcony found in Poetter Hall's southwest tower reveals the dramatic effects of light and shadow achieved by the contrast of brick and wrought iron. A large curved metal lintel supports the masonry, and a copper cornice runs above. Not only was riveted structural steel used to support the curvilinear balconies at the towers, but within the walls are found integral lateral iron ties. (Courtesy of SCAD Campus Photography.)

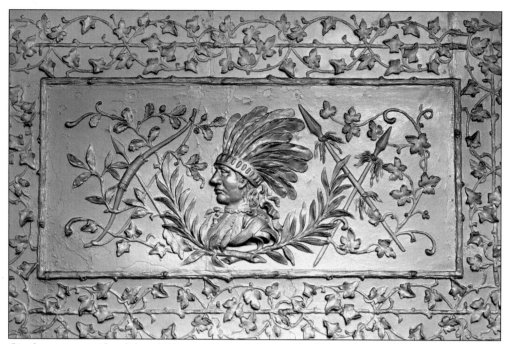

On the western side of the clubhouse's second floor is the library, later called the Tomochichi Room. The Tomochichi Club, a local political group, met at Poetter Hall during its early years. The ornate low relief plaster decoration in the overmantel of the fireplace features Native American motifs to honor the role played by Yamacraw chief Tomochichi in assisting General Oglethorpe and the first settlers in Savannah. Framed by branches, the stylized profile bust portrait of an Indian chief wears a feathered headdress (a type not actually worn by the Yamacraw) and is flanked by crossed spears and a bow and arrow to present a triumphal image of the chief, further reflected by the classical symbolism of the laurel leaves associated with triumph and the ivy associated with fame and eternal life. (Courtesy of SCAD Campus Photography.)

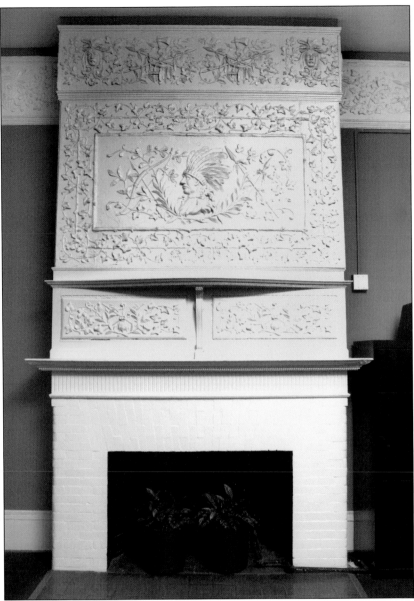

The library or Tomochichi Room, found above Poetter Hall's central entry hall overlooking Bull Street, was the most ornate room within the clubhouse. To the right of the hallway as visitors came upstairs was an arched opening leading to an extremely large lounging room with a corner loggia over Bull and Charlton Streets. The card room was to the right with a reception room and a lobby. A billiard room containing six billiard tables and a nearby wine room occupied the entire southern elevation with a second corner loggia overlooking Bull Street. The basement included a wine cellar. Also at the back was an entrance to a gallery overlooking the adjacent drill room, which doubled as an entertainment area. Attached to the eastern drill hall portion of the armory was a combination rifle range/bowling alley, now lost. The library's fireplace has a decorative plaster overmantel, a white tile surround, and a large hearth designed for burning wood. One of Preston's original design sheets was filled with much simpler, more utilitarian fireplaces. (Courtesy of SCAD Campus Photography.)

Seen in the original Preston plan are the flagpole and its massive iron support revealing hand tooling. The weathered and bleached heart pine flagpole is still in place, an appropriate accessory for an armory. In Preston's 1892 drawing, there are also flags flying from the tops of the two Bull Street corner turrets. The heavy, dark, wrought-iron scrollwork complements the hard burned red brick imported from Pennsylvania. Preston used Savannah gray brick for the building's foundations. Copper fascia elements are also used. Learning from earlier structural failures, Preston specified the pressed, fired brick for the exterior walls as opposed to the softer Savannah gray brick. He also specified that the mortar be of high quality and colored to complement the brick, creating a harmonious monochromatic effect. The immense flagpole, the two cannon, and the two turrets flanking the front entrance divide the arcade of four street level bays and contribute narrow vertical elements that pierce the horizontal mass of the building. (Courtesy of SCAD Campus Photography.)

The arched windows of Poetter Hall are characteristic features of the Richardsonian Romanesque style. The Romanesque revival swept America in the late 19th century. Its fantastic vision of medieval castles with turrets and crenellations was often used for public buildings. It was especially suitable for a military company's armory. Also typical are the deep openings and the asymmetrical façade with conical towers. The repeated pattern of the rounded brick arches curving over this window creates a sense of radiating movement. Brownstone sills and lintels are featured throughout the building. The carved stone capitals of the brick pillars have an anthemion and scroll pattern. The series of brick arches rises vertically across the wall surface. Each large arch on the ground floor is topped by two smaller arches or paired rectangles on the second floor and then by a triad of arches on the third floor. The openings of each floor diminish in size and depth, but the variety of intricate façade detail continues. (Courtesy of SCAD Campus Photography.)

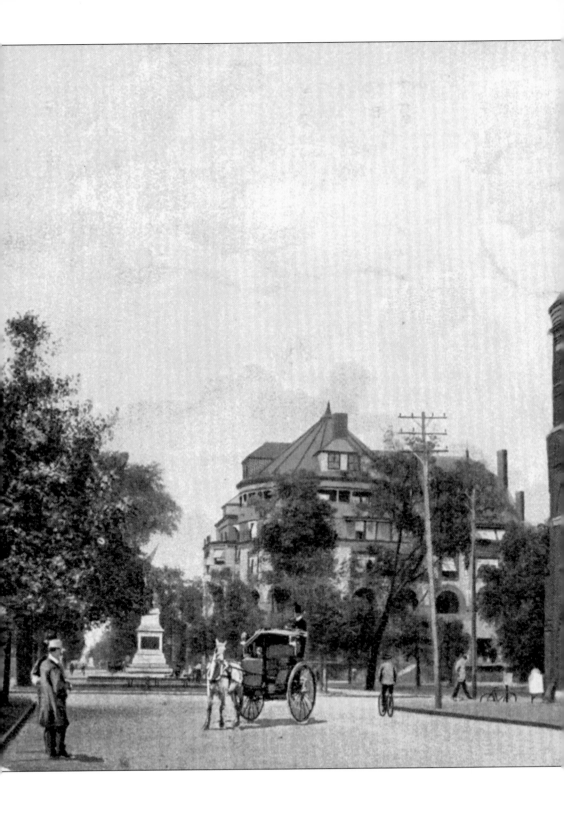

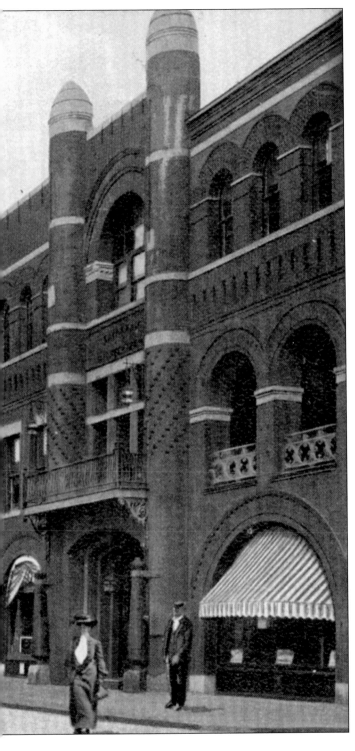

The Savannah Volunteer Guards Armory dominated the southeastern corner of Bull and Charlton Streets on Madison Square, one of Savannah's original historic squares. Bull Street is the central corridor of the historic city plan. This c. 1905 view shows the 1888 Jasper Monument by Alexander Doyle in the square. The Scottish Rite Temple on the southwestern corner across Bull Street has not yet been erected. On the northeastern corner of Madison Square appears (in the middle distance) another major Richardsonian Romanesque masterpiece by William Gibbons Preston— the DeSoto Hotel, dedicated in 1890 with Preston present. The venerable city landmark was demolished in 1966. Preston, a slightly younger contemporary of Henry Hobson Richardson, had followed in Richardson's footsteps to attend both Harvard and the Ecôle des Beaux-Arts in Paris. (Courtesy of the Georgia Historical Society, GHS Postcard Collection.)

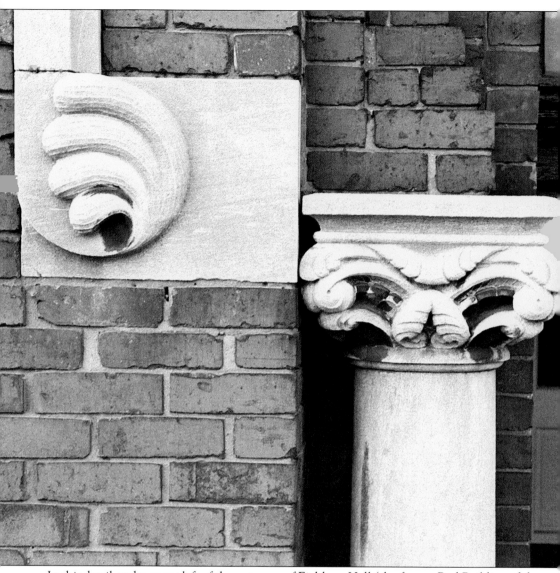

In this detail at the upper left of the entrance of Eichberg Hall (the former Red Building of the Central of Georgia Railroad), the soft, pale curvilinear forms of the stylized Ionic capital of a limestone column and the end flourish of the portico's arch contrast with the rectilinear lines of the hard fired red brick. The building dates to 1887, when a late Victorian aesthetic dominated architecture. Like Poetter Hall, the style is primarily Romanesque revival. The stone capital may be compared to those at the armory, which in both cases derive from medieval rather than truly classical forms. Victorian decoration frequently depended on pattern book compendia and on catalogues of readymade architectural elements. Local building suppliers also carried a stock of such items. Architects could create a look of restrained elegance or of ornamental exuberance depending on the building's function and the client's preference. Several styles were competing during this late Victorian era, and architects such as Alfred S. Eichberg and Calvin Fay, who designed this building, often moved easily between them. (Courtesy of SCAD Campus Photography.)

Two

THE CENTRAL OF GEORGIA

RAILROAD COMPLEX
A Victorian Landmark in Brick and Brownstone

The Central of Georgia Railway was chartered in 1833 as the Central Rail Road & Canal Company to provide transportation between Savannah and Georgia's interior. The first president of Central, elected in 1836, was West Point graduate and attorney William W. Gordon. Gordon was a mayor of Savannah and grandfather of Juliette Gordon Low, who founded the Girl Scouts. (Courtesy of Jack Boucher, photographer, and Library of Congress, Prints and Photographs Division, Historic American Engineering Record, GA, 26-SAV, 18-9.)

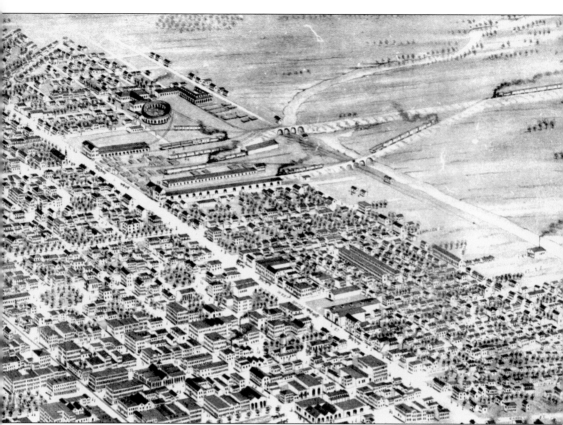

In this detail from an 1871 bird's-eye view of Savannah by panoramic artist Albert Ruger (1829–1899), the transportation corridor of West Broad Street (now Martin Luther King, Jr., Boulevard) is shown. The railroad complex to the south (seen in the upper left) then included the roundhouse and repair facilities, the two viaducts, the Up Freight and Down Freight Warehouses (now SCAD properties), and the office headquarters building, SCAD's Kiah Hall (the former Gray Building). It covered 35 acres on the site of the 1779 Siege of Savannah. The passenger depot may be seen to the south of Kiah Hall, which fronts West Broad Street. In 1855, a writer described the complex: "The buildings are new, of fine architecture and arrangement, forming a complete and symmetrical whole. . . . The cost of the buildings, land and machinery of this station, will be over $200,000." In 1857, the Central Railroad and Banking Company of Georgia invested in small vessels known as "steam packets," and by 1874, it had formed the Ocean Steamship Company. (Courtesy of the Georgia Historical Society, Map Collection # 1361 MP-15.)

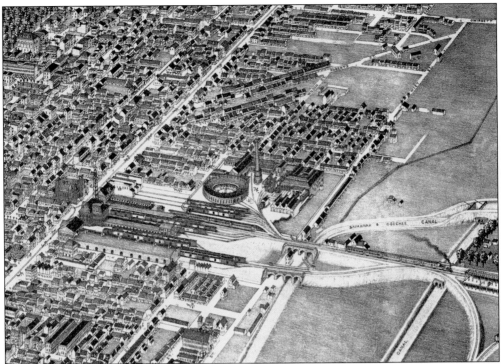

By the time of this 1891 "Bird's Eye View of Savannah" created by Augustus Koch (a Union Army cartographer who specialized in city views), the railroad's expansion to almost 1,800 miles required the Central of Georgia to construct a new office building. This was the Red Building (now known as SCAD's Eichberg Hall) and appears immediately above—that is, to the south—of the Gray Building (Kiah Hall). (Courtesy of the Georgia Historical Society.)

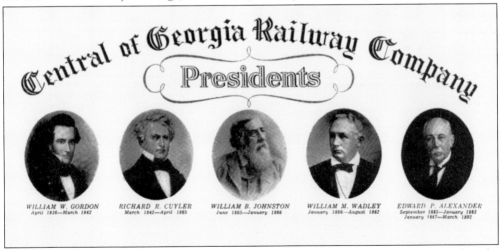

William M. Wadley (c. 1812–1882), the fourth president, was the general superintendent for Central Railroad during the 1850s when the complex was built. A New Hampshire mason, he served as both project foreman and designer. During 1862–1863, Wadley was appointed supervisor for all Confederate railroads as assistant adjutant general. Colonel Wadley was one of the great 19th-century railroad magnates. (Courtesy of the Coastal Heritage Society/Central of Georgia Historical Society.)

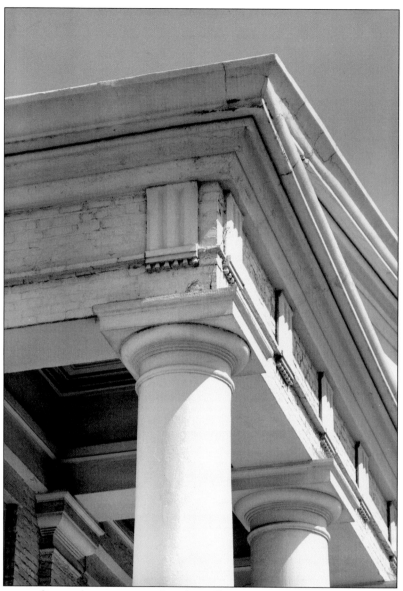

Shown here is the southeast corner of Kiah Hall's impressive portico entablature in 1976. Kiah Hall (the former Gray Building) at 227 Martin Luther King, Jr., Boulevard and Turner Street (once called West Broad and New Streets) was the original headquarters of the Central Railroad and Banking Company. A July 1855 article praised the railroad complex, crediting the design to William M. Wadley five years earlier. It termed the Savannah station "the most complete and elegant railroad station in the country (besides its being also one of the largest). . . . At the head of this building, fronting on West Broad street are the transportation and general offices of the Company [Kiah Hall]. This front is large and handsomely finished in the Roman Doric style of architecture. . . . On the south side of this building is a large court for carriages, and immediately beyond is the passenger depot." The latter was not yet finished in 1855 and is now the Savannah Visitors Center. (Courtesy of Jack Boucher, photographer, and Library of Congress, Prints and Photographs Division, Historic American Engineering Record, GA, 26-SAV, 57A-7.)

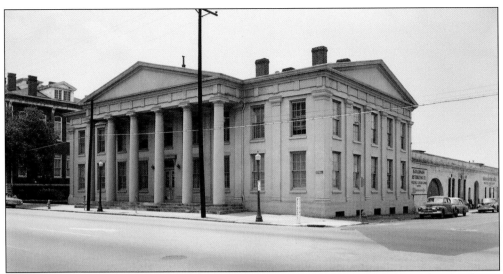

This 1962 view of Kiah Hall from the northeast shows a section of the Up Freight Warehouse behind the building. Constructed in 1853, the Up Freight Warehouse predated the 1855 headquarters building. In 1854, Savannah welcomed former President Millard Fillmore, holding the reception ceremonies in the "extensive warehouse of the Central Railroad." (Courtesy of Louis Schwartz, photographer, and Library of Congress, Prints and Photographs Division, Historic American Buildings Survey, GA, 26-SAV, 57A-2.)

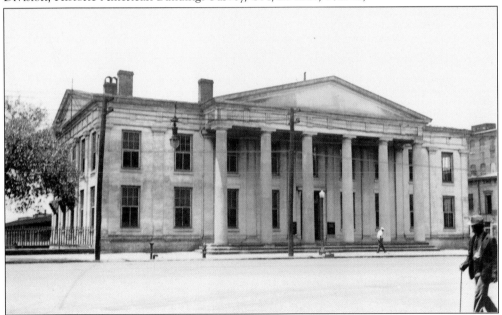

Kiah Hall is one of the finest examples of Greek revival architecture in Georgia with a design traditionally credited to Augustus Schwaab. This 16,968-square-foot, Savannah gray brick and brownstone building rises an imposing two stories above a basement level. It features a Tuscan Doric six-columned portico and a full entablature with triglyphs that continue around the portico and the building. Two-story brick pilasters articulate the bays. Kiah Hall is seen here around 1900 with its original stone steps. (Courtesy of the Georgia Historical Society, Walter Charlton Hartridge Collection, #1349:185:3125.)

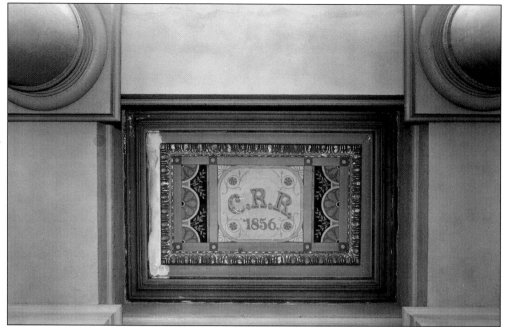

In the middle of the portico ceiling of Kiah Hall is inscribed the CRR monogram of the Central Rail Road and the date of the building's 1856 dedication, seen here in a 1962 photograph. (Courtesy of Louis Schwartz, photographer, and Library of Congress, Prints and Photographs Division, Historic American Buildings Survey, GA, 26-SAV, 57A-4.)

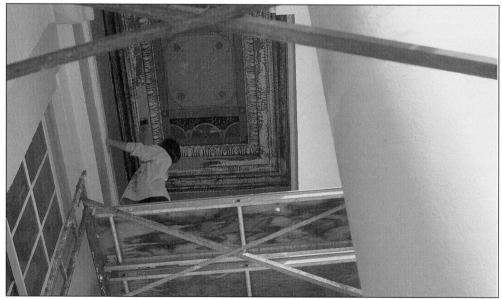

For almost 140 years, the building had been in continuous use as railroad offices. An initial, partial restoration of Kiah Hall took place in 1992 when the Savannah College of Art and Design first acquired the property, then in a much deteriorated condition. Here a historic preservation student is restoring the portico painting. The surface was cleaned, then stabilized with a water-based varnish that created a reversible, protective covering. (Courtesy of the Savannah College of Art and Design.)

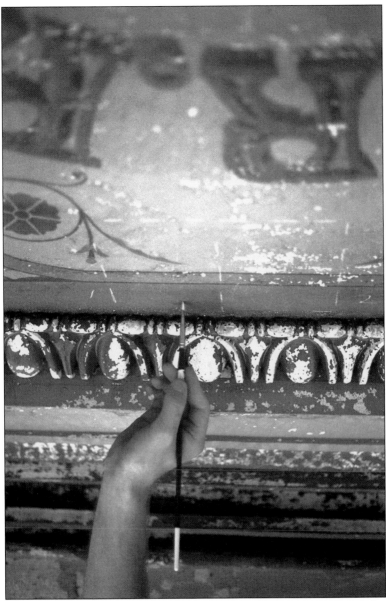

Here an advanced preservation student carefully restores the portico painting by inpainting on top of the new protective varnish. It is believed that the decorative painting in the portico was undertaken by skilled workers from the railroad's paint shop. Traces of a black-and-gold painting were discovered underneath the current painting. The earlier work reflected a simpler, more classical design that was superseded by the later Victorian ornamentation and colors. The original version would have been more in keeping with the building's pure Tuscan Doric style. After this initial phase of restoration was completed in 1992, the building was dedicated the following year to Dr. Virginia Kiah (1911–2001), a member of the college's board of trustees who was a pioneering African-American woman artist, a museum founder, and a proponent of the arts in education. (Courtesy of the Savannah College of Art and Design.)

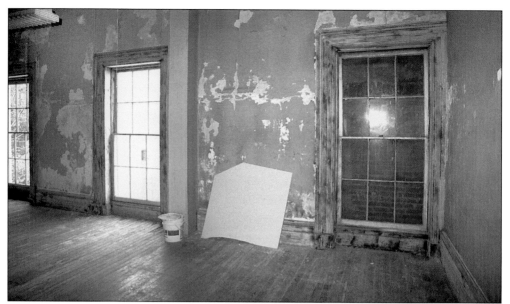

This view of a second-floor room shows the neglected interior before restoration. Kiah Hall features 14-foot ceilings. Much of the original heart pine flooring survives, as do the original baseboards and the stately door and window casings composed of three-piece elements in heart pine. The elaborate ceiling crown molding was cast in place. Many of the interior doors are also original. The large windows on the second floor admit floods of light. (Courtesy of SCAD Campus Photography.)

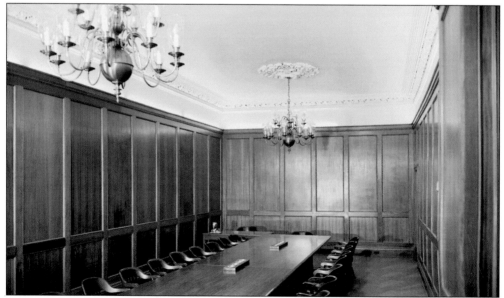

Here the Central of Georgia Railroad's 40-foot-long paneled boardroom on Kiah Hall's second floor may be seen as it appeared in 1962. The railroad had remodeled the building in major campaigns in 1913 and later in 1949, when the mahogany plywood paneling shown here was probably added. The two ceiling medallions are original. (Courtesy of Louis Schwartz, photographer, and Library of Congress, Prints and Photographs Division, Historic American Buildings Survey, GA, 26-SAV, 57A-5.)

An ornate seven-foot ceiling medallion is found over the second floor's central hallway, seen here in a 1976 photograph. The cast plaster medallion with its pomegranate and grape motifs is original and is thought to be the largest in Savannah. (Courtesy of Jack Boucher, photographer, and Library of Congress, Prints and Photographs Division, Historic American Engineering Record, GA, 26-SAV, 57A-11.)

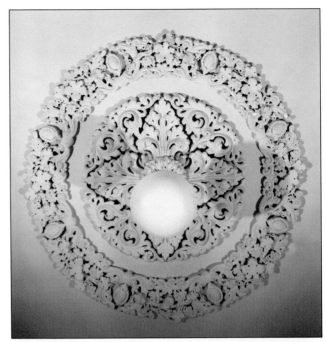

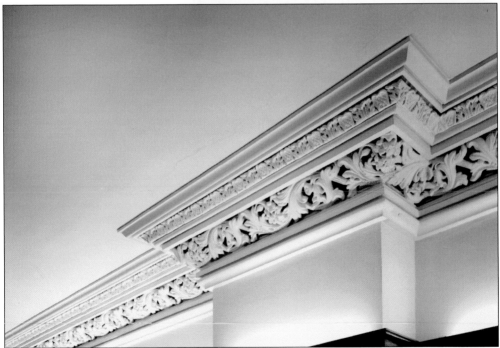

The cast plaster floral molding in the boardroom lines the ceiling edges. The adjacent 100-foot room, occupying the length of the eastern façade, also has a continuous grapevine ceiling molding. These sumptuous decorative elements match the grandeur of the exterior architecture and the consistent attention given to finishing details of high quality. (Courtesy of Jack Boucher, photographer, and Library of Congress, Prints and Photographs Division, Historic American Engineering Record, GA, 26-SAV, 57A-12.)

(*above left*) Upon the death in 1842 of the railroad's founder, W.W. Gordon, his brother-in-law Richard Randolph Cuyler (1798–1869) served as the second president of the railroad for 23 years, including the period during which Kiah Hall and the railroad complex were constructed. The prominent early photographer Abraham Bogardus, who began his New York City practice in 1846, took this albumen print of Cuyler. (Courtesy of the Georgia State Archives, Vanishing Georgia Collection.)

(*above right*) Near the front entrance is found what is traditionally identified as the president's office with its black marble fireplace (a 1976 view). Cuyler played an active role in the Confederacy through both his railroad and its affiliated banking business. Cuyler was captured by Sherman on the last train out of Savannah but released after dinner and questioning. (Courtesy of Jack Boucher, photographer, and Library of Congress, Prints and Photographs Division, Historic American Engineering Record, GA, 26-SAV, 57A-9.)

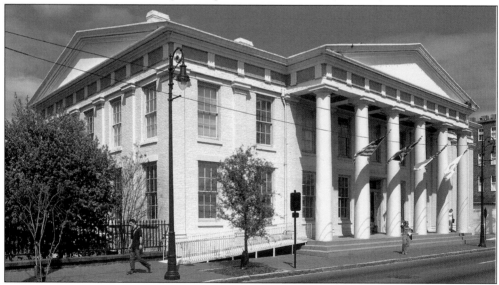

This contemporary view of the façade at Kiah Hall illustrates its new role as an art museum and study center for SCAD's Newton Center for British-American Studies, dedicated in May 2002. The Savannah Development and Renewal Authority has recently completed the new streetscape along this portion of Martin Luther King, Jr., Boulevard with a new median, brick sidewalks, lampposts, and landscaping. (Courtesy of SCAD Campus Photography.)

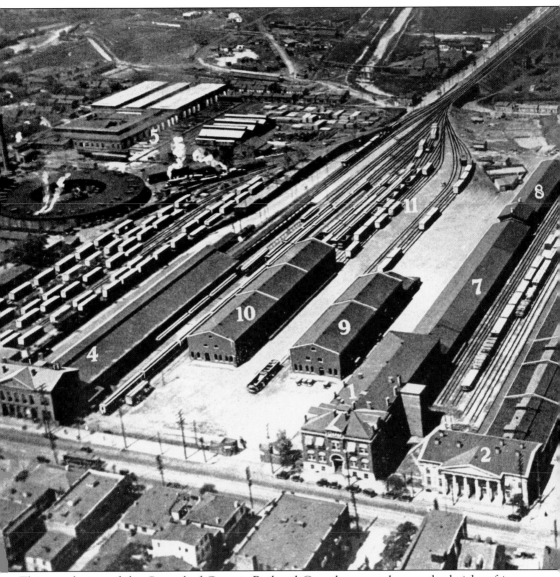

This aerial view of the Central of Georgia Railroad Complex was taken at the height of its prosperity in 1923, a century after the railroad was chartered. By 1929, the railway had almost 2,000 miles of track. After the railway switched to diesel engines serviced at its Macon depot and after the Great Depression, the decline of the Savannah complex began. The 1855 Kiah Hall is located at the lower right as #2. Behind it stretches the 800-foot-long Up Freight Warehouse of 1853. Paralleling the warehouse (#7) is the Down Freight Warehouse, which—with the 1887/1888 Eichberg Hall (#1)—presently houses the college's School of Building Arts. The passenger depot at the lower left (#4) is now the Savannah Visitors Center (completed shortly after Kiah Hall) with the Savannah History Museum at the back. In the upper left are the roundhouse and the historic repair shops. In 1976, the Central of Georgia Railroad Shops and Terminal was designated a National Historic Landmark, with the boundary enlarged in 1978. (Courtesy of Georgia Historical Society, GHS Photograph Collection.)

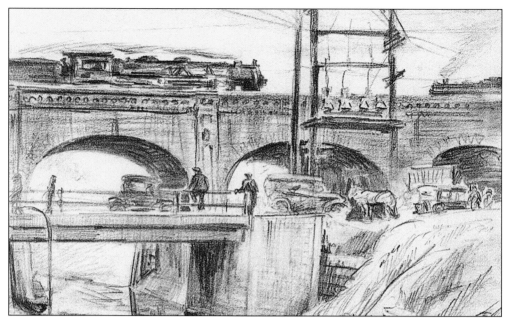

In the mid-1920s, a young local artist, Christopher A.D. Murphy (1902–1973), who had trained at the Art Students League in New York, sketched the South Viaduct behind the Down Freight Warehouse. The charcoal drawing vividly depicts the juxtaposition of the automobile era with the horse and the locomotive. Below the bridge is the Ogeechee Canal. (Courtesy of Mr. and Mrs. Leopold Adler II.)

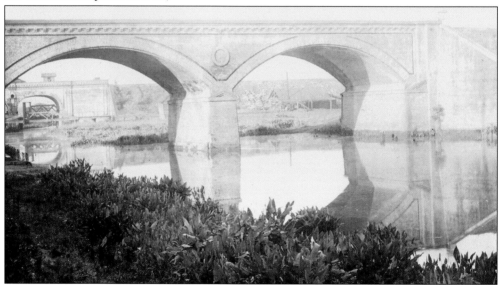

Around 1870, James S. Silva photographed the North Viaduct found to the west of the railroad yards. The North Viaduct with four arches dates to 1859–1860, while the adjacent South Viaduct with three elliptical arches was constructed in 1852–1853. Both were constructed of Savannah gray brick with elaborate detailing such as corbelling. Augustus Schwaab, who became the Chief Engineer for the Central of Georgia Railroad in 1865, designed the North Viaduct, now a SCAD pedestrian walkway. (Courtesy of the Georgia Historical Society, James S. Silva Collection, # 2126, Scrapbook 2.)

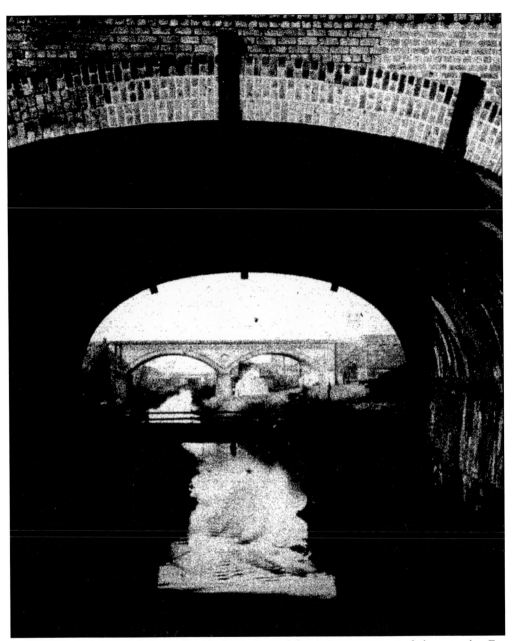

Frances Benjamin Johnston (1864–1952) was one of the women pioneers of photography. For about a decade in the 1930s, she participated in the Carnegie Survey of Architecture in the South, where she traveled through nine Southern states. She spent some time in Savannah, where she photographed the two viaducts together. SCAD's North Viaduct may be seen in the distance. Johnston had studied art at the Academie Julian in Paris and at the Washington Art Students League. Her first camera was a gift from George Eastman, a family friend. Her interest in vernacular architecture is reflected here. She was later honored by the American Institute of Architects for her contributions to architectural photography. The picturesque viaducts with their arcades were the main conduits into and out of the railroad yards. (Courtesy of the Library of Congress, Frances Benjamin Johnston Collection.)

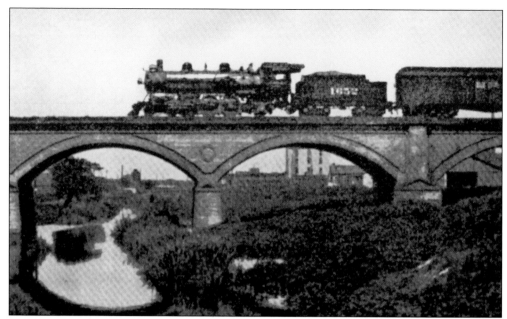

In 1924, this photograph was taken of Engine 1652 on its way to Atlanta with train No. 1. Long a familiar local sight, the evocative view of a train on a bridge became an icon of industrial progress, then later one of nostalgia. (Courtesy of the Coastal Heritage Society/Central of Georgia Historical Society.)

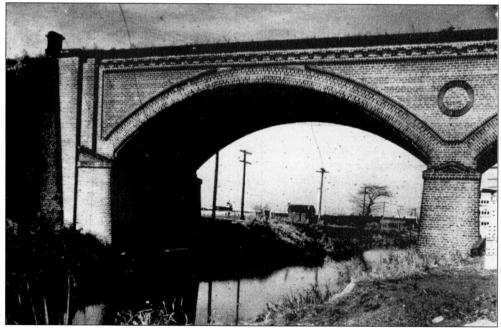

In this side elevation of the North Viaduct, Frances Benjamin Johnston exhibits its clean lines and simple powerful form in the 1930s. The North Viaduct has four segmental arches, each with a 48-foot span, with decorative roundels found in the spandrels. The bridge still serves as an integral axis of movement in its current use as a pedestrian walkway between campus buildings. (Courtesy of the Library of Congress, Frances Benjamin Johnston Collection.)

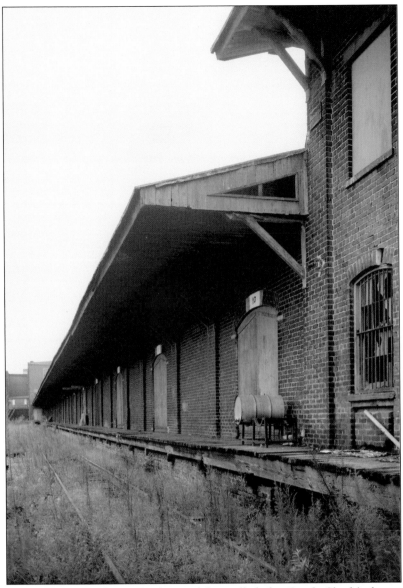

The Down Freight or Produce Warehouse (also called the South Sheds), located behind Eichberg Hall (the Red Building), was built in 1859, thus slightly postdating the 1853 Up Freight Warehouse to the north. The warehouse is a one-story Savannah gray brick construction with porches along both the north and south elevations. A later two-story office extension is found at the west end. Brick pilasters and arches delineate the walls, while the rafters of the roof trusses set up an interior space pattern. This view from 1976 shows the loading platform and canopy of the outbound freight structure, which is 600 feet long by about 35 feet but was originally longer. The 21,377-square-foot warehouse property was acquired by the Savannah College of Art and Design in 1991 and rehabilitated by 1995 to serve as classroom, studio, and workshop space. (Courtesy of Jack Boucher, photographer, and Library of Congress, Prints and Photographs Division, Historic American Engineering Record, GA, 26-SAV, 58B-5.)

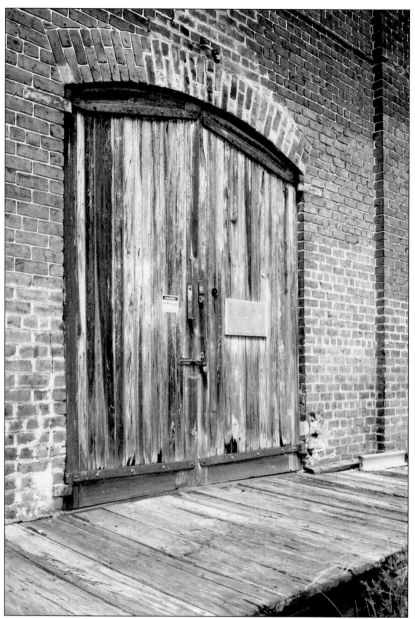

This 1976 image of the south side of the Down Freight Warehouse shows one of the heavy wooden double doors crowned with a brick arch. When the warehouse was first built in 1859, beyond it towards West Broad Street were large cotton yards where bales of cotton were brought. In January 1865, the depot at Central Railroad was occupied by Union troops. During Sherman's March to the Sea, although the Central Railroad tracks had been destroyed (with the rail bent into "Sherman's hair-pins" as Grant joked), the rolling stock was safe in Savannah and was returned to the railroad in 1866, including 14 locomotives, 113 box cars, and 7 passenger cars. (Courtesy of Jack Boucher, photographer, and Library of Congress, Prints and Photographs Division, Historic American Engineering Record, GA, 26-SAV, 58B-7.)

The original doors of Eichberg Hall (formerly the Red Building) at 229 Martin Luther King, Jr., Boulevard convey the powerful design sense of the late Victorian craftsmen. The sliding oak pocket doors recess into the walls. Not presently used, they form a significant architectural feature and contribute to the Romanesque revival design. (Courtesy of SCAD Campus Photography.)

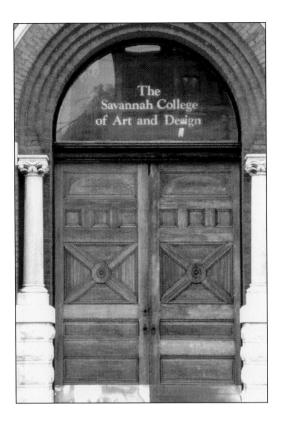

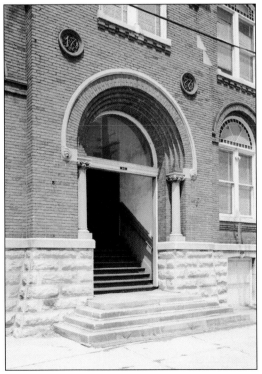

Deeply recessed brick arches and terra cotta and limestone ornamentation characterize Eichberg Hall's impressive eastern portico, which projects outwards at the central elevation. In the terra cotta medallions flanking the entrance is found the stylized date "1887." The original stone steps may be seen in this 1976 photograph. (Courtesy of Jack Boucher, photographer, and Library of Congress, Prints and Photographs Division, Historic American Engineering Record, GA, 26-SAV, 58A-6.)

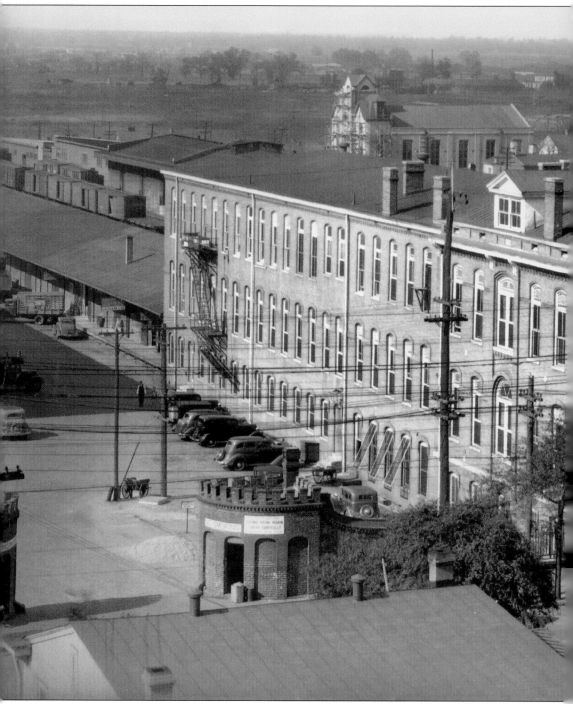

This aerial view from about 1936 shows the east façade of Eichberg Hall with the 1910 extension (without chimneys) by H.O. Young behind it, followed by the Down Freight Warehouse. Part of Kiah Hall is visible to the right, as well as a section of the 1860 Cotton Yard gates on the left. When Central of Georgia Railroad required more office space in 1887, Alfred S. Eichberg and Calvin Fay were commissioned to design the new three-story structure.

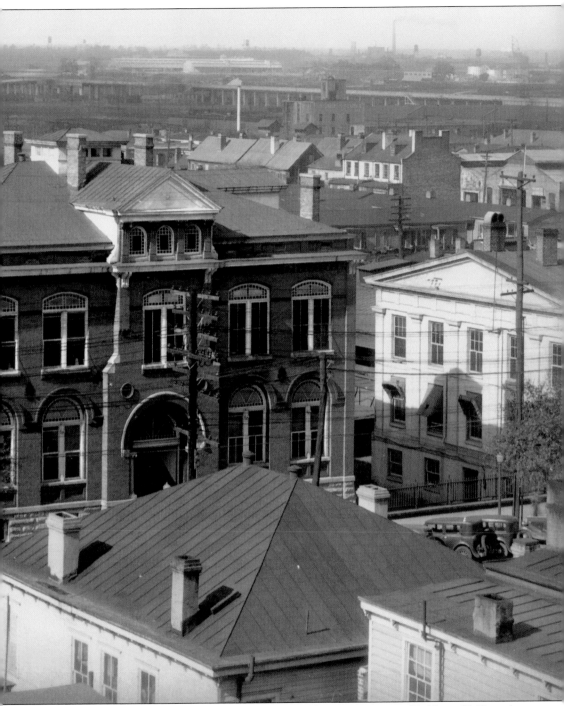

It was completed in February 1888 with Patrick J. Fallon as contractor. Eichberg Hall's style is primarily Richardsonian Romanesque with some Queen Anne elements. It is built of hard-fired red brick laid in a running bond pattern. At the basement level on the east façade is rusticated limestone with hand tool marks visible. (Courtesy of the Georgia Historical Society, Cordray-Foltz Collection.)

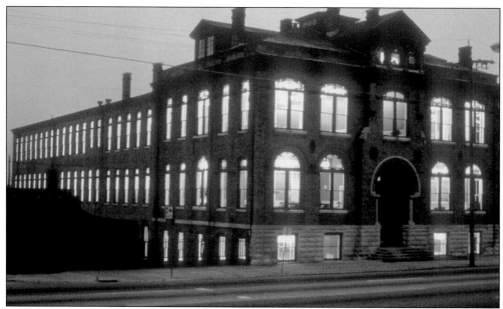

The college acquired the approximately 48,658-square-foot structure in 1988 with most of the renovation completed by 1990. Named after its architect and seen here in a dramatic night view, Eichberg Hall features large windows. On the more elaborate east elevation (repeated on the south side), the second-floor windows are paired and linked by fan windows. On the third floor, there are similar pairs of windows, but now surmounted by transom windows. The arched fourth-floor dormer windows repeat the stained glass motif. (Courtesy of SCAD Campus Photography.)

This interior detail looks out through one of the third-floor transom windows. Around the clear center glass and in the vertical middle row are stained-glass squares richly colored in tones of red, blue, and amber. Such rectangular stained glass was often used in Queen Anne–style architecture. Arched transoms are also found in the 1910 extension. (Courtesy of SCAD Campus Photography.)

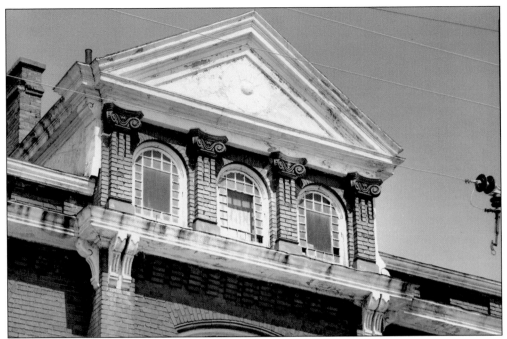

Above Eichberg Hall's entrance is a gable that creates a terminating pediment to the façade's elevation, seen here in a 1976 photograph. Three arched dormer windows are separated by brick pilasters with scrolled terra cotta capitals. Below is a metal cornice supported by decorative metal brackets. Elaborate corbelling reflects the attention to intricate detail in the brickwork. (Courtesy of Jack Boucher, photographer, and Library of Congress, Prints and Photographs Division, Historic American Engineering Record, GA, 26-SAV, 58A-5.)

 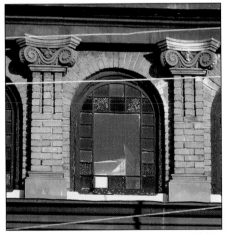

(*above left*) Terra cotta accents are found across the façade. A detail of the "1887" roundel is dense with a floral background. Terra cotta arches also curve over the third-floor windows and link to form a stringcourse. On the second-floor level, there are molded brick accents. (Courtesy of SCAD Campus Photography.)

(*above right*) This detail of the central dormer window at the top of Eichberg Hall's entrance bay captures the subtle play of surface texture and complementary small scale patterns—bricks, terra cotta, small stained-glass window panes, and corbels—all of which work together, accented by narrow shadows. (Courtesy of SCAD Campus Photography.)

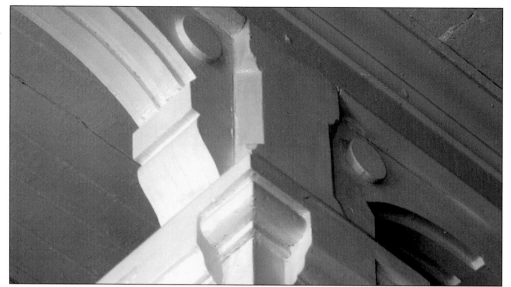

Interior details include abstract Carpentry Gothic patterns, as in this detail from the capital of a pillar. A geometry of curves and corners forms a rich wooden pattern. When the railroad complex was designated a National Historic Landmark in 1976, the National Park Service noted that it formed "the oldest and best example of the mid-19th century integrated railroad shops complex in the United States." (Courtesy of SCAD Campus Photography.)

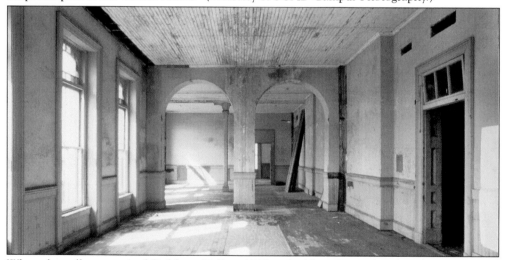

When the college acquired Eichberg Hall in 1988, it had long been abandoned since Central of Georgia Railroad vacated the premises in 1966. A preliminary 1981 plan to develop the buildings into condominiums resulted in a development company acquiring the property in 1982. A lawsuit was brought by local preservationists to halt the demolition. This view before restoration provides a glimpse of the dilapidated condition of the interior as well as its potential. Large sash windows and interior arched openings define generous spaces. The initial renovation required restoring 185 windows, in addition to doors, stairs, wooden columns, the bead board ceiling and wainscoting, and the interior plaster. Various functional improvements were also completed, such as installing fire stairs, an HVAC system, electricity, restrooms, and other additions. The exterior masonry was restored as well, with plant growth removed. (Courtesy of SCAD Campus Photography.)

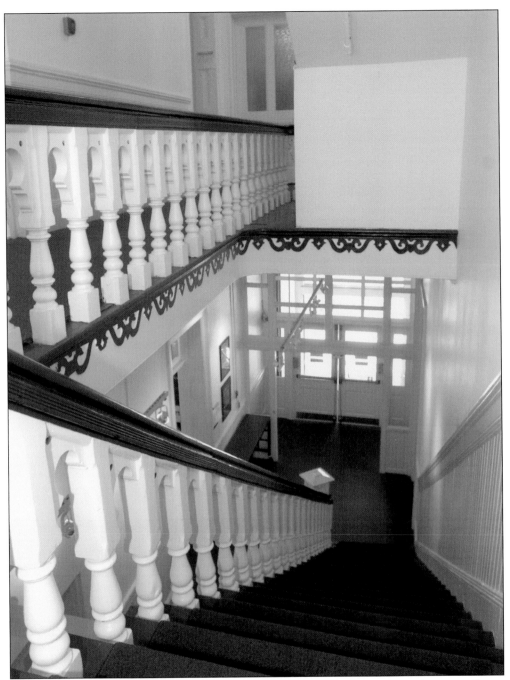

Upon entry into Eichberg Hall, a central wooden stairway leads visitors to the upper floors. This view looking down the main stairway shows the fine craftsmanship and sense of design. Here the turned balusters rise to sawn posts, and a polished wooden handrail runs along the top. Victorian pine stair brackets provide an ornamental element along the lower edge. Similar brackets could be purchased by the foot from decorative millwork companies. (Courtesy of SCAD Campus Photography.)

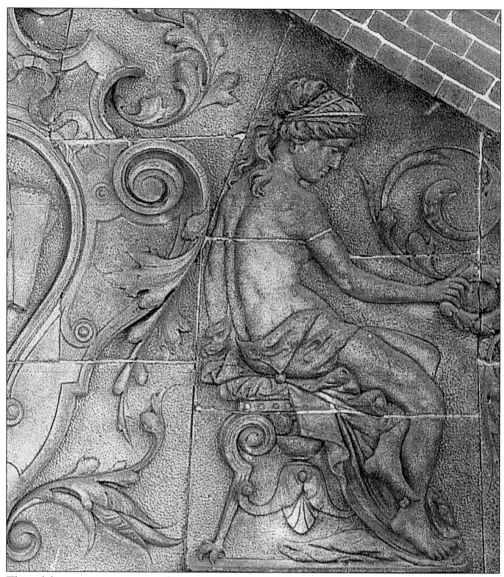

This elaborate terra cotta pediment, with classical female figures and arabesques flanking a central cartouche, was designed to be seen from below at a distance. It is found at the summit of the entrance bay of Henry Hall, the former Henry Street School. Terra cotta ornamentation was frequently used in the late Victorian era to create a monochromatic effect when paired with red brick. This panel and others on Henry Hall were manufactured by Southern Terra Cotta Works of Atlanta, the largest such enterprise south of the Ohio River. This pediment required the terra cotta to be pieced together with a scale that suggests the magnificence of the building it adorned. Designed by Gottfrid L. Norrman in 1892, the Henry Street School introduced an imposing example of the Queen Anne style to Savannah. (Courtesy of SCAD Campus Photography.)

Three

A QUARTET OF
TURN-OF-THE-CENTURY SCHOOLS
Savannah Academic Traditions Continued

In 1986, the Savannah College of Art and Design acquired the former Henry Street School. Two years later in August 1988, it purchased four other abandoned Victorian schools—Barnard Street School, Anderson Street School, 37th Street School, and Beach Institute. The college restored the latter, a venerable African-American institution, donating it to the King-Tisdell Cottage Foundation. It rehabilitated the remainder to serve as academic and studio buildings. (Courtesy of SCAD Campus Photography.)

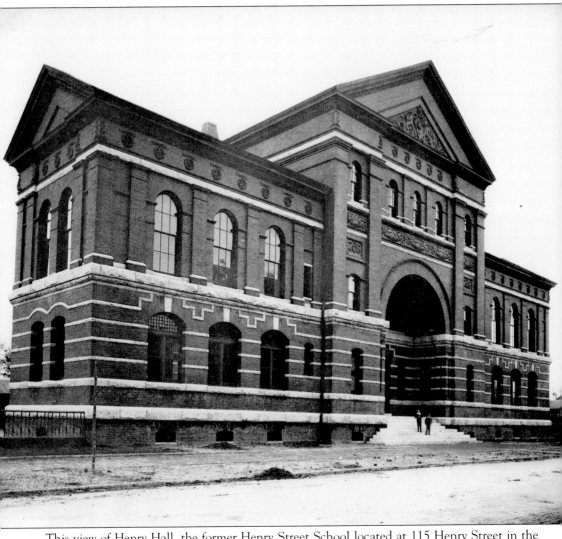

This view of Henry Hall, the former Henry Street School located at 115 Henry Street in the Savannah Victorian District, shows the structure as it appeared around 1895. It was then new, with plans for the $30,000 structure by the Swedish architect Gottfrid Norrman having been accepted in March 1891. The builder was Andrew J. Aylesworth. The three-story, 28,295-square-foot, red brick Queen Anne revival–style building features lavish terra cotta ornamentation, a gabled central pavilion, and a monumental arched entrance, reflecting the Richardsonian Romanesque style. Above the entrance elevation, the third floor once served as an auditorium. Brick pilasters and stone separate the arched windows on the second floor, while granite stringcourses create horizontal and geometrical fret patterns across the surface. An iron fence marks the perimeter of the school grounds. In 1975, the building ceased to be used as a school. Acquired and renovated by the college in 1986, it was the first of the college's school buildings to be given new academic life. (Reproduced from Charles H. Olmstead, *Artwork of Savannah*, Chicago: W.H. Parish, 1893. Courtesy of the Georgia Historical Society.)

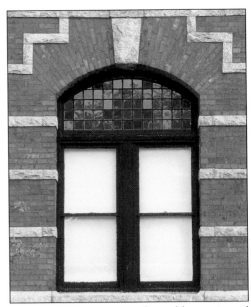

(*above, left*) This foliate and ribbon patterned terra cotta swag ornament framed by rusticated granite is found on the entrance bay frieze. The terra cotta was manufactured by Southern Terra Cotta Works of Atlanta, founded by P. Pellegrini and Z. Castleberry in 1871. (Courtesy of SCAD Campus Photography.)

(*above, right*) The coupled windows of the first floor of Henry Hall are surmounted by transom windows with multiple square lights. (Courtesy of SCAD Campus Photography.)

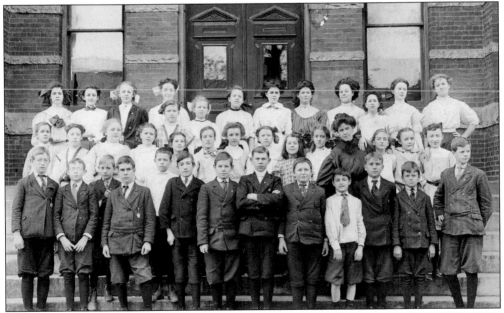

This view of schoolchildren at the entrance of Henry Hall dates to about 1910–1915. The school was the first one built by the Chatham County Board of Education. The short list of three architects included a design by Eichberg, preferred by the board but too expensive. (Courtesy of the Board of Public Education for the City of Savannah and the County of Chatham.)

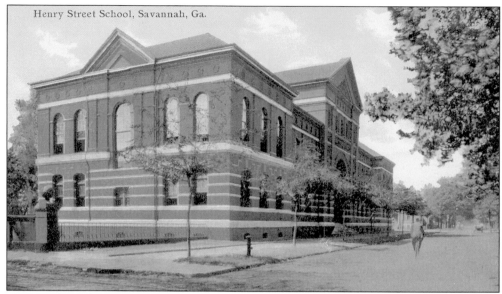

In 1910, the architect Hyman Witcover designed the additions at each end of Henry Hall. He continued the exterior wall treatment that Norrman had designed and repeated the original gables at the side elevations of the building. The new additions project forward at the front façade. Dual staircases lead to the upper floors. This historic postcard records the changed appearance. Streetcar tracks may be seen in the foreground. (Courtesy of the Savannah Collection, Jen Library, SCAD.)

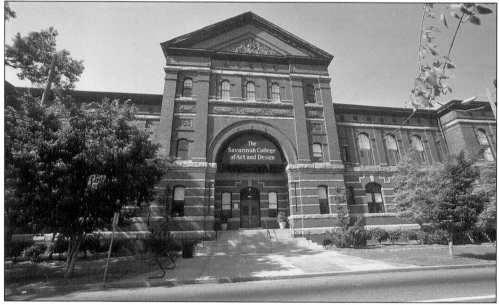

The Henry Street School was restored by the college for its new use as studio and classroom space in 1986. Most of the architectural features remain the original ones by Norrman and sensitively adapted by Witcover. Henry Street, like the later abandoned school buildings acquired by the college, had previously served as a neighborhood anchor. With the rehabilitation of these large public spaces, the area has been revitalized. (Courtesy of SCAD Campus Photography.)

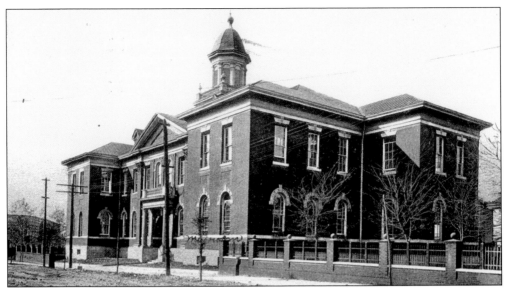

In 1896, Atlanta architect Gottfrid L. Norrman designed the Anderson Street School (412 East Anderson Street) for $20,000, using a blend of the classical and Colonial revival styles. The college acquired and renovated the structure in 1988. Here the Anderson Street School is seen *c.* 1905. (Courtesy of the Savannah Collection, Jen Library, SCAD.)

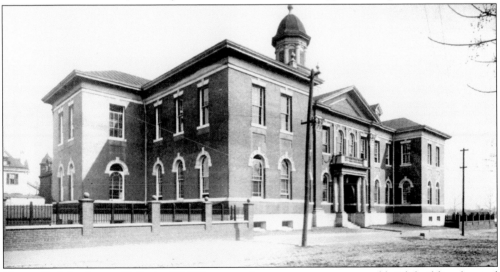

Now called Anderson Hall, the 20,478-square-foot, two-story ornate red brick building located in the Savannah Victorian District rests on a limestone foundation. The modernity of the school (shown here around 1900) was much admired, including its hollow walls for coolness, steam heat, and the southern exposure of its classrooms. Later changes included the 1960s addition of a cafetorium (a dining hall). The strong vertical mass is emphasized by the pilasters flank the entrance elevation, the gable, and the cupola. The portico with a parapet is flanked by paired columns. Limestone arches curve around the top of the windows on the first floor and on the second floor's central bay, but they are replaced by rectangular window lintels on the remainder of the building. The restrained elegance of the design contrasts with the more ornate revival styles. (Reproduced from Charles Edgeworth Jones, *Art Work of Savannah and Augusta*, Chicago: Gravure Illustration Co., 1903. Courtesy of the Georgia Historical Society.)

Suggestions of classicism abound, as seen here in the Corinthian capital above a portico column at Anderson Hall. Gray terra cotta was used for the capitals, pilasters, columns, and bases. Other materials include limestone, granite, and concrete. (Courtesy of SCAD Campus Photography.)

Reflecting the simplicity and geometry of the building is the wrought-iron fence with cast-iron posts at Anderson Hall. Schools generally enclosed their playgrounds, and here Norrman took advantage of the opportunity to create a powerful linear element. (Courtesy of SCAD Campus Photography.)

The octagonal cupola at the summit of Anderson Hall is a domed lantern shape with faceted pilasters and a deep cornice. The original louvers in the openings and wooden balustrade railing are no longer present. The school was built in response to the growing population of Savannah. Before its first year was over, the second-floor hallway had to be cordoned off to create four classroom spaces beyond the 12 initially designed. (Courtesy of SCAD Campus Photography.)

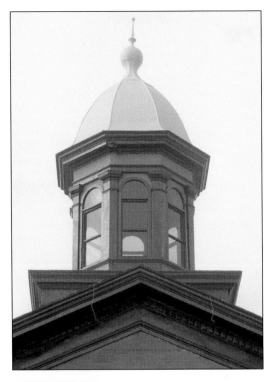

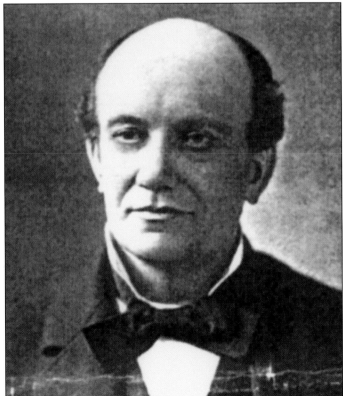

Gottfrid (Godfrey) L. Norrman, born in Sweden in 1848 and trained in Copenhagen and Germany, was a world traveler. He eventually settled in Atlanta at the time of the Cotton States Exhibition, designing some of its largest buildings. He had a thriving practice around the Southeast, with several major Savannah commissions. The *Southern Architect* described the Anderson School as "an ornament to the city" and the architect as a "true artist." (Reproduced from Walter Cooper, *The Cotton States and International Exposition and South Illustrated*: The Illustrator Co., 1896, p. 262, Courtesy of the Atlanta History Center.)

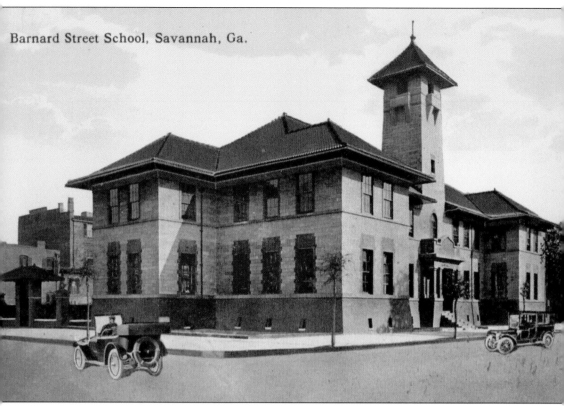

Barnard Street School, Savannah, Ga.

Using the same design as the 1896 Anderson Street School, Gottfrid L. Norrman reinterpreted the floor plan to construct the Barnard Street School at 212 West Taylor Street in 1906, presenting his plans for the $75,000 structure to the Chatham County School Board in November 1905. Today the building is called Pepe Hall in honor of Dr. Marie Pepe, a member of the college board of trustees with a distinguished background as an art historian and educator. The two-story, 20,759-square-foot Mediterranean revival–style building on Chatham Square has a battered brick basement, a terra cotta roof, and a central tapering bell tower above the entrance portico with its four simple square columns. Contrasting color emphasizes the different materials used to detail the wall surface. Originally the walls had a scored stucco treatment with a rusticated appearance as seen here c. 1915. Sandstone creates a segmented effect at the windows. Pepe Hall's great hipped roof is covered with tile. (Courtesy of the Georgia Historical Society, GHS Postcard Collection.)

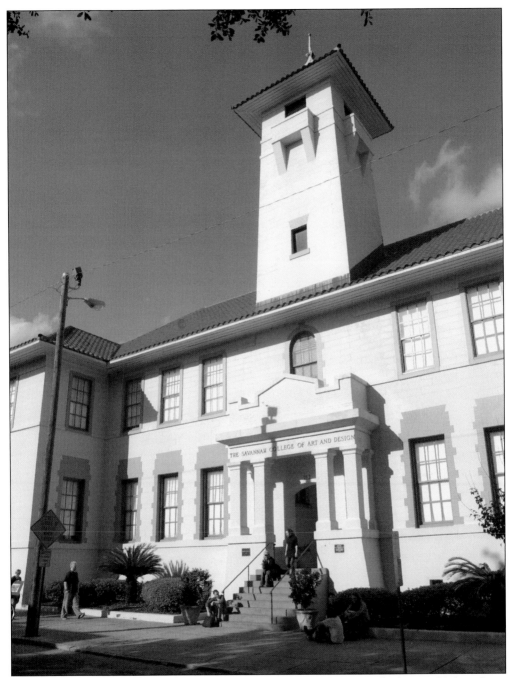

The front elevation of Pepe Hall is shown here with its bell tower, which rises 24 feet above the roof line. The tower has balconies on all four sides and is topped by a pyramidal tile roof and a copper spire. Dual staircases are found at either end of the hallways. Hardwood floors and 14-foot-high ceilings provide spacious expanses for academic classes. The original doors, door casings, and hardware are still present. Also original is the wainscoting. Part of the building's restoration campaign in the mid-1990s included replacing the deteriorated roof with terra cotta tiles acquired from the original roofing company. (Courtesy of SCAD Campus Photography.)

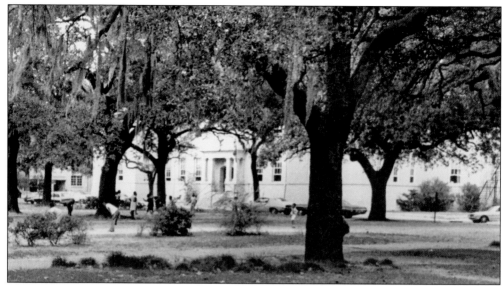

Pepe Hall housed administrative offices from 1956 to 1961, after it had closed as a school because of dwindling enrollment (with only about 200 students). However, in 1961 it reopened as a school for African-American students until integration. This view through Chatham Square from the early 1960s shows the square's traditional use as a playground for students. (Courtesy of the Georgia Historical Society, GHS Photograph Collection.)

On the east side of Pepe Hall is a terra cotta roofed gate and a wall topped by wrought iron, which encloses what was once a playground. The Mediterranean revival motif is carried out also in these elements. Originally, the west side had a similar arrangement, but a dining hall was later added on that side. (Courtesy of SCAD Campus Photography.)

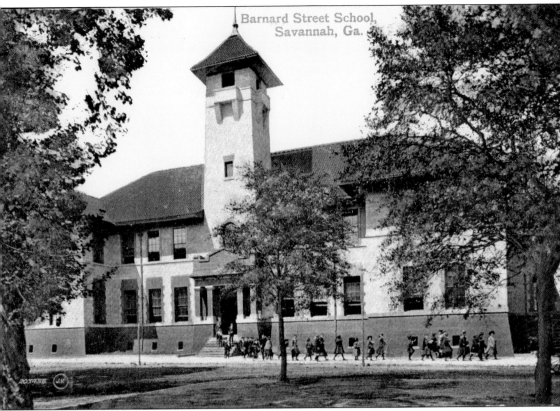

This view of Pepe Hall from about 1910 shows a line of school children in front. The original Barnard Street Elementary School of 1854, sometimes called the Boys' High School and Boys' Grammar School, was designed by the New York architect John S. Norris. It was the first public school in Savannah. General Sherman's Union Army used the school as a military hospital during the Civil War. The girls went to the Massie School, constructed about the same time also by Norris. The site's continuous use as a school from the mid-1850s was complemented by its peaceful location on the square. The Savannah College of Art and Design acquired the building in 1988 with three other schools. (Courtesy of the Georgia Historical Society, GHS Postcard Collection.)

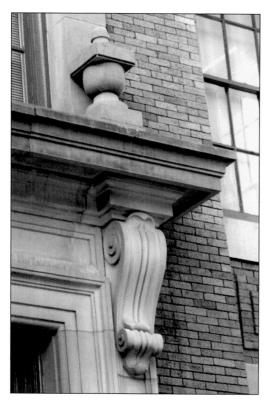

The 37th Street Elementary School was built in 1912 by architects Henrik Wallin and Edwin Young in the Prairie style. Acquired in 1988 and now named Wallin Hall after its architect, the 25,887-square-foot building features buff brick sloping walls, extremely deep eaves, and an ornamental bell tower. This detail shows the cornice and bracket from the portico. (Courtesy of SCAD Campus Photography.)

Located at 312 East 37th Street in the Thomas Square Trolley Historic District, Wallin Hall's distinctive architecture has such typical Prairie-style features as the hipped roof and the deep projecting eaves of the building. This detail of the west projection of the façade offers a good view of the columns and brackets of the tower. (Courtesy of SCAD Campus Photography.)

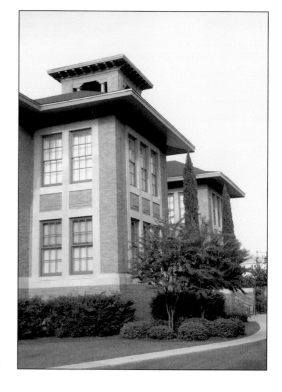

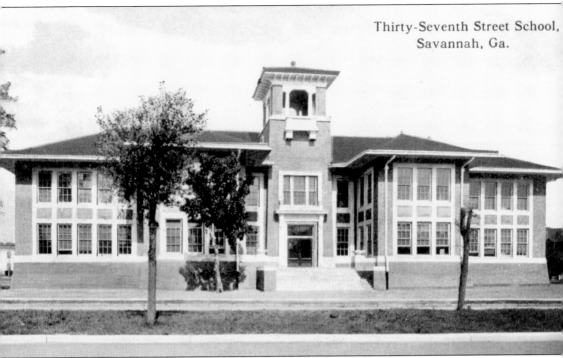

Thirty-Seventh Street School, Savannah, Ga.

In this historic postcard of Wallin Hall from about 1925, the building's strong horizontal orientation may be seen, interrupted by the height of the portico with its large doorway rising through the square tower's projecting elevation. A low sloping roof contributes to the horizontal character, as do the stone framing elements that unite the windows into geometric panels. When Frank Lloyd Wright popularized the Prairie style, he also emphasized open plans. The pale buff brick contrasts with Savannah's usual masonry, but it conforms to Prairie-style structures that were painted a tan or light color to blend with their wood elements or natural setting. The construction of Wallin Hall reflected the shifting population of the city as new suburbs developed to the south. (Courtesy of the Georgia Historical Society, GHS Postcard Collection.)

In the early 20th century, the Beaux Arts style turned to classical roots to create buildings with beautiful detailing, symmetry, and balance. Often these structures were public buildings. This detail from Pei Ling Chan Gallery (the former Exchange Bank) suggests the reintegration of the classical. (Courtesy of SCAD Campus Photography.)

Four

MONUMENTS OF CIVIC SOCIETY
Banks and Jail, Church and Charity

During Savannah's prosperous years at the end of the 19th century, the city had completely recovered from the Civil War and surged ahead economically. There was a building boom. Public institutions and the structures that ordered civic life were designed and built. A number of these significant buildings have been converted to new use for the Savannah College of Art and Design campus. (Courtesy of SCAD Campus Photography.)

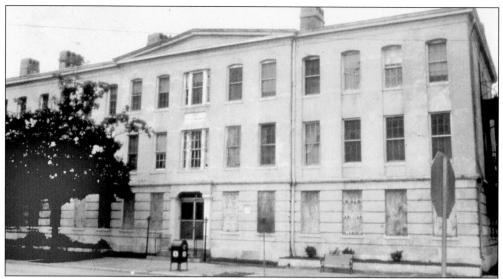

Upon her death in 1853, Mrs. Dorothea Abrahams willed her land at 548 East Broughton Street and East Broad Street to the Savannah Widow's Society, along with money to construct a home for elderly widows. This view of the Abrahams Home (now Norris Hall) shows its boarded up windows before its restoration. (Courtesy of SCAD Campus Photography.)

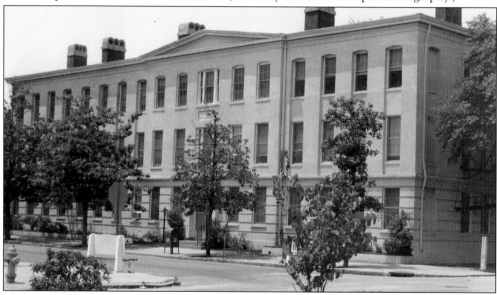

The Abrahams Home (seen here around 1950) was designed by New York architect John S. Norris. When it opened in April 1858, it was described as "plain and substantial without any effort at display. It is 90 by 40 feet, and three stories high. You enter a hall by a door in the center which is crossed at right angles by another hall, running the entire length of the building. On this floor are ten chambers and a dining room. The second and third floors contain eleven chambers each. . . . The chambers are 32 in number, and each has a fire place and a closet. The entire cost is something under $14,000. . . . This building will stand as a monument to the liberal beneficence of its founder, and a testimonial of the skill of the architect, Mr. J.S. Norris." (Courtesy of the Georgia Historical Society, GHS Photograph Collection.)

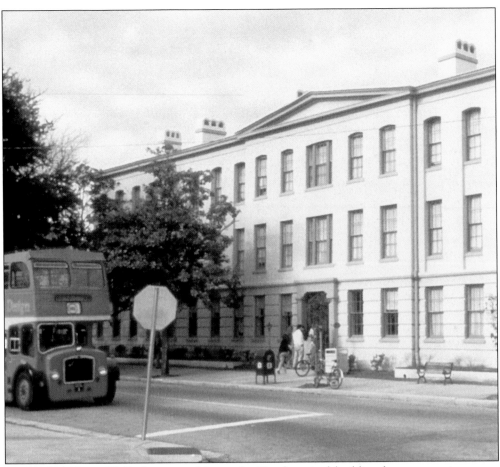

Now called Norris Hall after its architect, the Greek revival building has two stories over a rusticated first floor with an exterior highlighted by a pedimented central bay and an enclosed garden. Numerous fireplaces are found throughout the 14,040-square-foot building, which was acquired in 1989 and rehabilitated in 1990. The fireplaces were features for the comfort of its residents, of whom there were 36 in 1889. The exterior of the building also has a metal cornice, scored stucco work, a shoestring course, entrance pilasters and lintel, a brownstone entrance stoop, and rusticated joints in the masonry of the first floor. Norris was sensitive to the functions of the buildings he designed. The Custom House would be imposing, the Green-Meldrim House sumptuous, the First Presbyterian Church ornate, and the Massie School of 1856 simple. The Abrahams Home, as a charitable institution, was deliberately kept plain, a feature admired by the 1858 writer above. The comparable charity of the time was the Mary Telfair Home for widows with children. The view above shows the façade after restoration. (Courtesy of SCAD Campus Photography.)

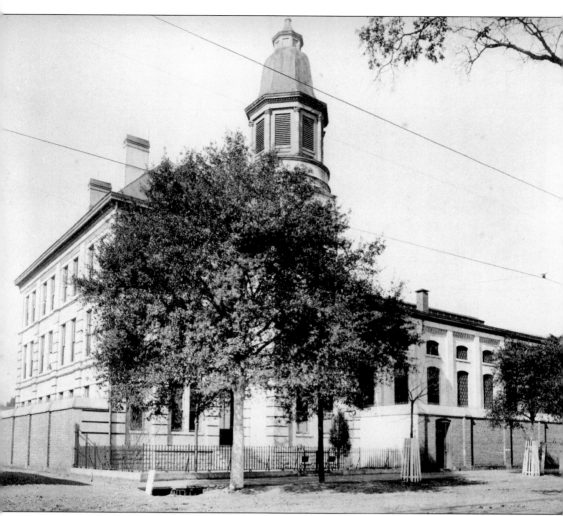

When Chatham County officials decided to replace the old jail in 1885, they held an architectural competition for the new $53,000 building, selecting McDonald Brothers (Harry P. and Kenneth McDonald) of Louisville, Kentucky. The latter arrived in July 1886, and work commenced. The local project architect was DeWitt Bruyn with W.F. Bowe as the contractor. The jailers' residence would be on the south with a 93-foot high clock tower overhead. The cell block paralleling Habersham Street was to be a model with prisoners separated by gender. It would have four tiers with 117 cells (each five by ten feet), two smaller basement-level dungeons, a cell for condemned prisoners with a trapdoor overhead, an infirmary, and innovations such as speaking tubes, an elevator to bring food to the upper floors, and gas lighting. The jail was built in 1887, with prisoners transferred in 1888. A fire in 1898 destroyed the first tower. This photograph predates the fire and shows the tower's original appearance. (Reproduced from Charles H. Olmstead, *Artwork of Savannah*, Chicago: W.H. Parish, 1893. Courtesy of the Georgia Historical Society.)

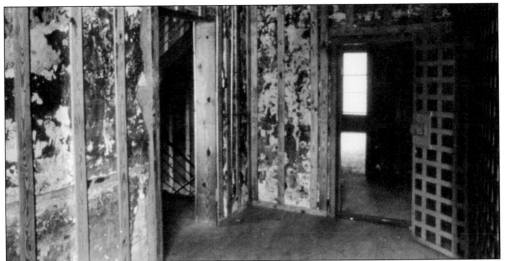

The Chatham County Jail at 235–239 Habersham Street remained in use from 1888 to 1978, renovated in 1957 by Bergen and Bergen Architects. In 1983, a group of investors called the Bastille acquired the property to develop it as condominiums. The cell block area was gutted, but the project failed. In 1986, they donated the property to the college. Above is an interior view before restoration. (Courtesy of SCAD Campus Photography.)

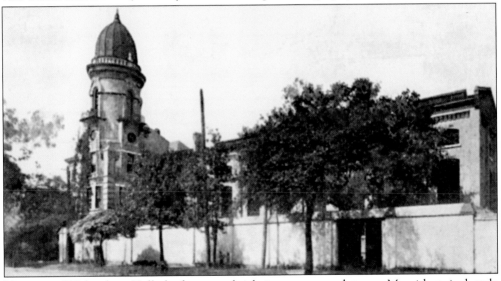

Now named Habersham Hall, the four-story brick, iron, stone, and stucco, Moorish revival–style structure consists of 42,884 square feet, with 12,500 square feet of usable space. The jailers' residence and cell block have a rusticated granite base with upper walls of Savannah gray brick. They are covered with stucco and scored to resemble stone masonry and quoins. The cell block has brick piers and corbelling, stone window sills, and arched windows. The jailers' residence has stone sills and lintels that form horizontal bands. Above there is a brick corbel level. The majestic tower, added after 1898, is a Moorish turret that replaced the original Byzantine dome. It rises 106 feet, with four cast-iron balconies and a decorative metal cornice. This photograph was made shortly after the new tower was built in 1898. The street is not yet paved, and the 15-foot-high wall that surrounded the cell block is visible. (Courtesy of the Savannah Collection, Jen Library, SCAD.)

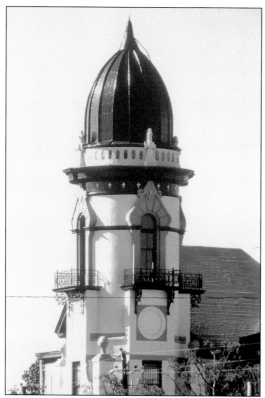

The initial renovation of Habersham Hall was completed by 1988, with a later 2004 campaign in the dome area. The use of exotic elements was one of the late Victorian revival styles, where inspiration could be drawn from various Oriental or Middle Eastern styles, including Turkish, Byzantine, Egyptian, Moorish, and others. (Courtesy of SCAD Campus Photography.)

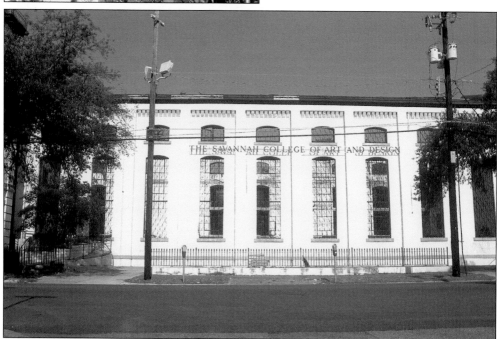

While Habersham Hall has undergone many interior changes, the exterior is still virtually intact, with the exception of the roof over the cell block. This view from the east shows the gutted cell block area. (Courtesy of SCAD Campus Photography.)

Mills B. Lane was vice president of the Citizens Bank when the building was constructed in 1895; B.A. Denmark was president. After a merger, the Citizens and Southern Bank moved to a new building by 1910. (Courtesy of the Georgia Historical Society, VM 2003.)

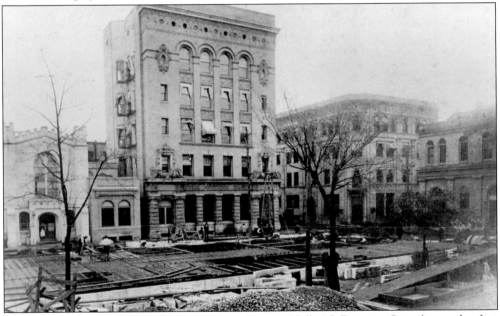

The 5.5-story 1895 Citizens Bank building (Propes Hall, 15 Drayton Street) was the first skyscraper in Savannah. It was designed in the Chicago style of Louis Sullivan by Atlanta architect Gottfrid L. Norrman, who incorporated a hydraulic elevator with fireproof and steel-frame construction. Thomas McMillan did the construction work for M.T. Lewman. An artisan who previously worked on the Biltmore Estate in Asheville carved the sculptures with a local craftsman. These include rusticated pillars on the ground level supporting a plain entablature and projecting belt course, garlanded spandrels between the fourth- and fifth-floor windows, lion's head cartouches surrounding oval oculi on the fifth-floor corners, deep scrolls, and an upper foliated terra cotta frieze with ocular openings, dentils, projecting cornices and a parapet. This 1907 view shows the building before the adjacent structure facing Johnson Square was erected. (Courtesy of the Georgia Historical Society, GHS Photograph Collection.)

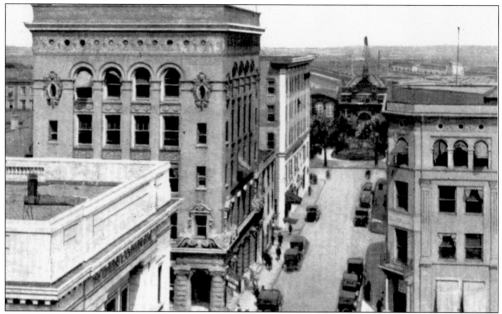

Drayton Street is shown here around 1915 with Propes Hall is on the left. The upper floors are faced with buff brick with matching terra cotta. (Courtesy of the Georgia Historical Society, Cordray-Foltz Collection, VM 1360:11:11.)

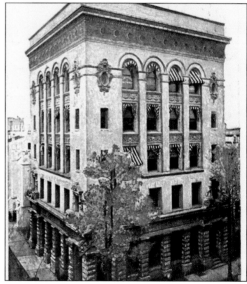

(*above left*) This elaborate detail from a c. 1920 view of the northeast corner above the ground floor shows the richly carved ornamentation with a broken, scrolled, swan-neck pediment over the recessed window. The small beehive in the foreground is repeated elsewhere on the belt course and may refer to the productive industry of bees, both a classical and a Masonic symbol. Garlands, volutes, and finials abound. (Courtesy of the Georgia Historical Society, Edward Girard Photograph Collection # 1374:2:6.)

(*above right*) The striped awnings are open on the east façade to protect the office workers from the morning sun. This early image, from c. 1905, shows trees growing in the as yet unpaved street. (Courtesy of the Georgia Historical Society.)

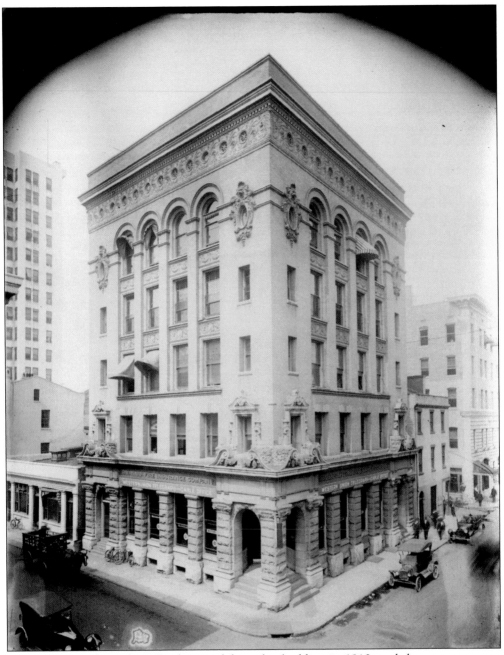

The Citizens and Southern Bank moved from this building in 1910, and the new tenants—whose signs may be seen here—included the Savannah Fire Insurance Company and Western Union. The horse-drawn wagon to the left, bicycles, and early cars all share street space. The interior has an iron and marble staircase, while the main floors are of Georgian marble. Total construction cost $60,000, an unusually low amount for such a major edifice. (Courtesy of the Georgia Historical Society, VM 1374.)

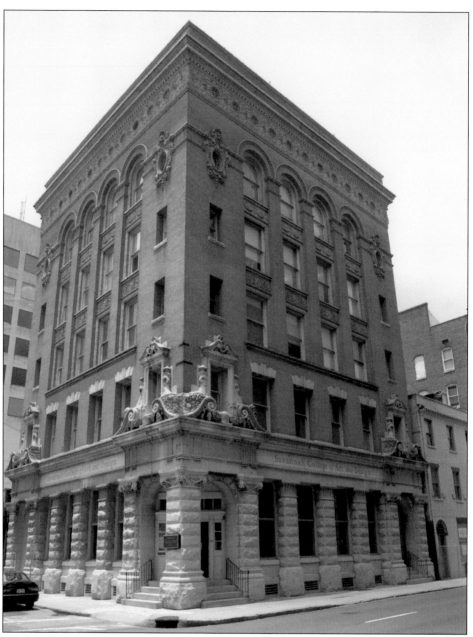

The 16,800-square-foot building was acquired and renovated by the college in 1997. It was renamed Propes Hall after a charter member of the college's board of trustees. This contemporary view of the structure, now used for office space for financial aid and the bursar's office, shows that it retains its grandeur. When it was built, Propes Hall heralded a "new era of building in Savannah." Especially noteworthy was the fireproof construction, with a steel frame and interior iron columns covered in clay tiles. There were iron fire escapes and an asphalt and brick roof. When the building was renovated, the new elevator had to be custom made to fit the historic elevator shaft. The bank building has been called "Norrman's most enduring and most beautiful business structure." (Courtesy of SCAD Campus Photography.)

Built in 1919 as the Exchange Bank, the small 4,824-square-foot building at 322 Martin Luther King, Jr., Boulevard is a Beaux Arts gem. Here shown before restoration, an iron railing that originally marked off the bank officers' space has been removed, but the vault is still visible in the lower center. (Courtesy of SCAD Campus Photography.)

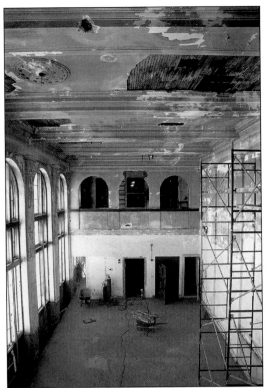

The Exchange Bank was acquired by Citizens and Southern Bank in 1928, with the building then leased to Savannah Bank and Trust from 1950 to 1971. The latter installed the drive-up teller window around 1954. The beautiful exterior detailing includes cast-stone Ionic pilasters, a projecting pediment over the West Broad Street entrance with an arched window above, and the series of tall arched windows along the north façade. (Courtesy of SCAD Campus Photography.)

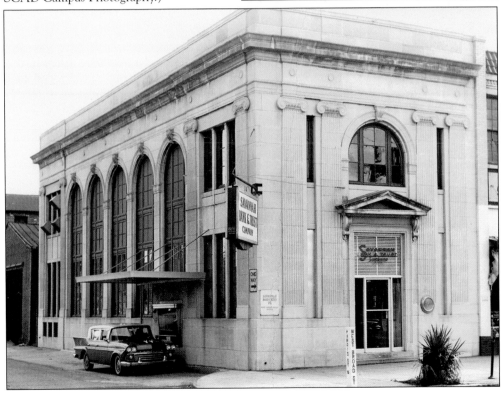

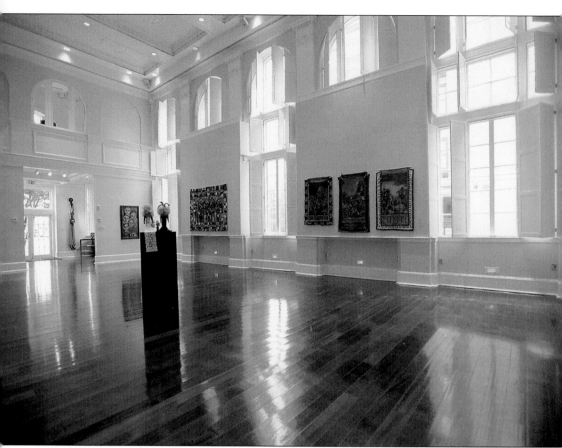

In the bank building acquired by the college in 1989 and renovated in 1996 as gallery space, the interior was kept as an uninterrupted whole. Here the windows are temporarily blocked for an exhibition by African-American artist Faith Ringgold. The first exhibition to use the renovated space was a video installation by Bill Viola as part of the Olympics arts programming. The 21-foot-high ceiling and the expanse of light are enhanced by the restored interior, which, as on the exterior, is elegantly appointed with classical elements, such as Corinthian and Ionic pilasters and ornate plaster ceiling moldings. The building has been renamed the Pei Ling Chan Gallery, in honor of the family who acted as benefactors. A vacant lot to the south was also acquired in 1989 and renovated to become the Pei Ling Chan Garden for the Arts with an outdoor amphitheater. (Courtesy of SCAD Campus Photography.)

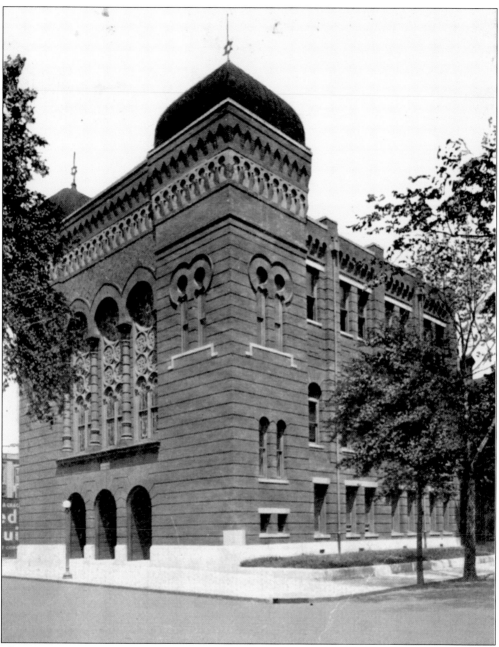

The Congregation B'nai B'rith Synagogue (28,834 square feet) was designed in 1909 by Hyman Witcover as a four-story, exotic revival building with keyhole arches defining the windows, arabesque patterns in the window glass tracery on the entrance elevation, intricate carved and corbelled detail along the top of the building, and the Moorish-style domes on the west façade corners. The Orthodox congregation had separated from the Congregation Mickve Israel in the 19th century and established its own place of worship. When Witcover designed the synagogue, a prominent example of Moorish revival used for synagogue architecture was the 1870 Central Synagogue in New York City. This view from the mid-20th century shows Stars of David as dome ornamentation. (Courtesy of the Georgia Historical Society, GHS Postcard Collection.)

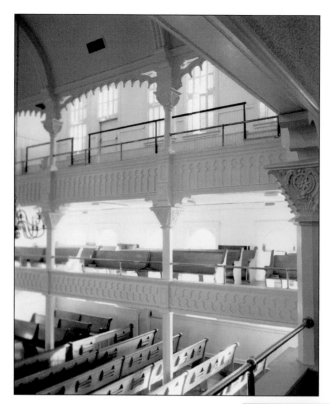

The structure at 112 Montgomery Street later housed the Saint Andrew's Independent Episcopal Church, from 1970 to 2002. The light-filled interior shown here reflects these religious usages. Two stories of balconies surround the central space, supported by polygonal wooden pillars with carved wood Byzantine capitals. Acquired by the college in 2003 after the church had vacated the premises, the building is presently a student center. (Courtesy of SCAD Campus Photography.)

This portrait of the architect Hyman Wallace Witcover (1871–1936) was painted around 1925 to honor his various high positions among the Scottish Rite Masons, where he was elected to the 33rd degree. He began his architectural career with the Eichberg firm and later opened his own Savannah office in 1906, receiving major commissions, including the Savannah City Hall, the Scottish Rite building, and the Congregation B'nai B'rith Jacob Synagogue. (Courtesy of Scottish Rite, Savannah.)

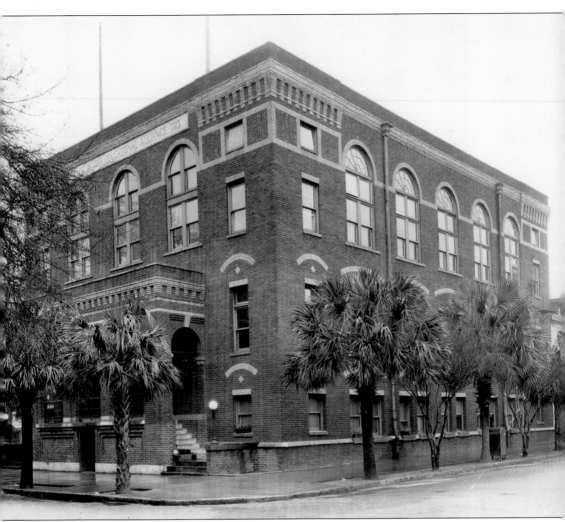

Overlooking Pulaski Square, this 15,350-square-foot, 3-story red brick building located at 328 Barnard Street occupies a site once used for a dwelling. The present edifice was built in 1914 to house the Jewish Educational Alliance's community center, including a gym and club rooms (seen here around 1935). The first JEA president from 1914 to 1915 was Benjamin H. Levy. Its initial role as a charitable structure on a trust lot continued, and later owners included the Tabernacle Baptist Church and the Salvation Army. It was acquired by the Savannah College of Art and Design in 1995 and converted into a residence hall (previously leased for that purpose). The windows become progressively more elaborate as they move up the three stories, with those on the third floor coupled under a fanlight, and a continuous stone stringcourse goes around the structure. A fancy brickwork entablature defines the corners and is repeated at the top of the large arcaded portico. (Courtesy of the Georgia Historical Society, Cordray-Foltz Collection.)

An immense and abandoned department store on Savannah's deteriorated main street (Broughton Street) became the college's library. The building was made up of three different structures—one from the end of the 19th century, then subsequent expansions eastward, first in 1925, then in 1950, so that the entire city block was occupied and united behind a single storefront. The empty store had become an eyesore across the years. Acquired by the college through the generosity of Federated Department Stores, with renovations made possible also by additional donations from Jim and Lancy Jen, the 85,000-square-foot space became once again a vibrant center for patrons, but this time for ideas, advanced information technology, and creativity rather than for commerce. This detail of a stair railing from the college's Jen Library suggests the fresh interpretation of the space. (Courtesy of SCAD Campus Photography.)

Five

AN AMERICAN VERNACULAR
OF INDUSTRY AND COMMERCE
From Main Street and the Carriage Trade
to the Automobile Era

American vernacular elements and structures create a historic preservation landscape that is often overlooked because of their very familiarity and comparatively recent history. However, many of these ordinary buildings have an inherent architectural value. They are simple and utilitarian but often with hidden treasures and surprising potential. (Courtesy of SCAD Campus Photography.)

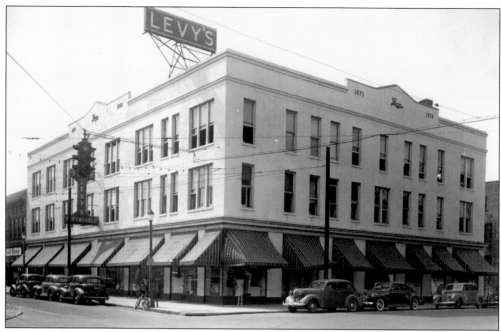

Benjamin H. Levy opened his first retail store in Savannah in 1871, occupying several downtown sites. Levy's Department Store moved to the southeast corner of Abercorn and Broughton Streets in 1925, where a Savannah gray brick building from about 1890 already stood. By combining the new structure with the existing one behind a unified storefront, a spacious square department store was created, shown here around 1945. (Courtesy of the Georgia Historical Society, Cordray-Foltz Collection.)

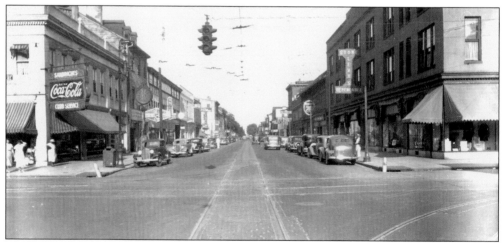

A 1940s view of Broughton Street with the streetcar tracks visible and with a brick pavement shows the city's commercial district. Levy's Department Store is on the right. In both of these images, the ground floor level is the glass storefront, while windows on the next two levels are predominantly arranged as single windows in rows on the Abercorn Street façade or in groups of three on the Broughton Street northern façade. In both cases, there are some irregularities in the rhythm due to the combination of the earlier building with the 1925 one. (Courtesy of the Georgia Historical Society, Cordray-Foltz Collection.)

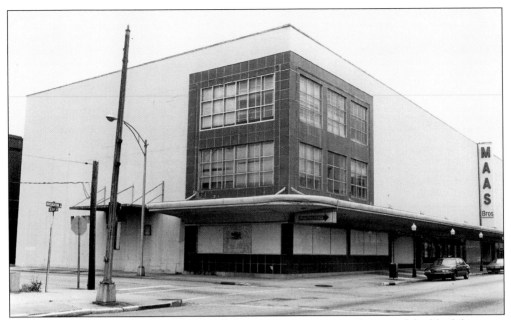

In 1950, Levy's Department Store expanded to the east, acquiring the rest of the block between Abercorn and Lincoln Streets, with a total square footage of 85,000. The newest section of the store had a concrete structure, creating three different structural systems—wooden rafters (still visible) on the Abercorn original building, the 1925 extension, and the 1950 addition. Most of the windows were now covered behind a new wall surface, with the exception of large floor-to-ceiling windows on the second and third floors on the Broughton Street corners. (Courtesy of SCAD Campus Photography.)

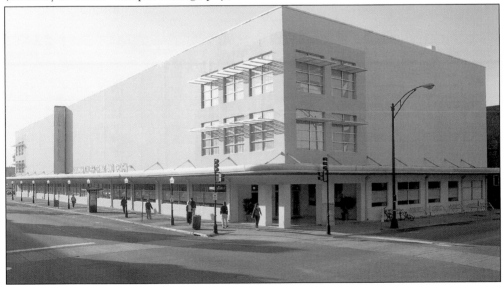

In 1986, B.H. Levy merged with Maas Brothers, and the store at 201 East Broughton Street was renamed. Through the generosity of Federated Department Stores, the Savannah College of Art and Design acquired the long-abandoned property in 1996. It was renovated to reopen as the Jen Library in April 1999, named after college benefactors Jim and Lancy Jen. (Courtesy of SCAD Campus Photography.)

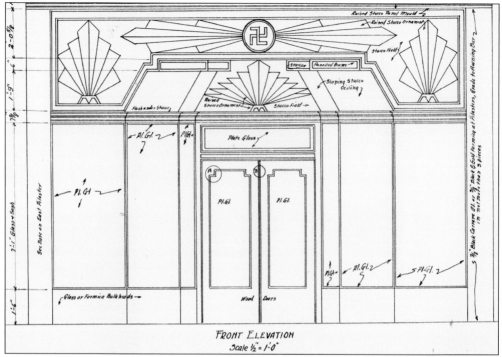

The architect for many of the changes to Levy's Department Store during the 20th century—including the 1950 renovation—was prominent local architect Cletus Bergen. Among his other plans, he drafted a new storefront façade design in 1931 that updated the appearance of the store to an Art Deco style. The geometric designs reflect the suggestion of a pediment in the shaped parapet of the 1925 building. (Courtesy of the Georgia Historical Society, Bergen Collection VM 1363:218.)

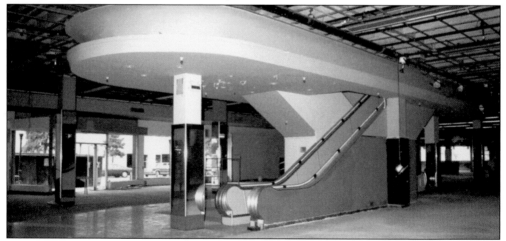

The 1950s remodeling included the installation of Savannah's first escalator (shown here before the building's restoration). Levy's Department Store was the scene of a pivotal event which launched Savannah's Civil Rights Movement: the first "sit-in" occurred in the Azalea Room lunch counter. Subsequent protests and the boycott of Savannah businesses led by NAACP leader W.W. Law eventually resulted in the peaceful integration of city institutions. (Courtesy of the Georgia Historical Society.)

The college's restoration of the building with the help of local architect Lee Meyers involved keeping the open floor plan as much as possible, including glass-walled offices, classrooms, study carrels, and other areas. An open grid system was installed as a ceiling. Low book stacks set among wide aisles encouraged accessibility for patrons with disabilities. The numerous network connections enabled hundreds of computers and computer homework labs to be installed. City code would not permit the old escalator to remain in use, and it was replaced with a glass stairway—a signature element of the rehabilitated building. (Courtesy of Deborah Whitlaw, photographer.)

The Indian Street Power Station (522 Indian Street) overlooking the Savannah River was built in 1882 with an addition in 1894. The first electrical company in Savannah was the Brush Electric Light & Power Company incorporated in 1882, with a trial light placed in the market later that year and the first streetlights installed the following year. Four light towers, powered by coal, were erected. (Courtesy of SCAD Campus Photography.)

The power station is now called Hamilton Hall, after Samuel P. Hamilton, the first president of Brush Electric Light & Power Company of Savannah. It is a 27,085-square-foot, two-story, red brick building detailed with corbelling and a stepped façade on Indian Street. Acquired in 1991, the building was rehabilitated by 1993. This interior view of the northern 1882 section before restoration shows the broad expanses of space and arched windows. (Courtesy of SCAD Campus Photography.)

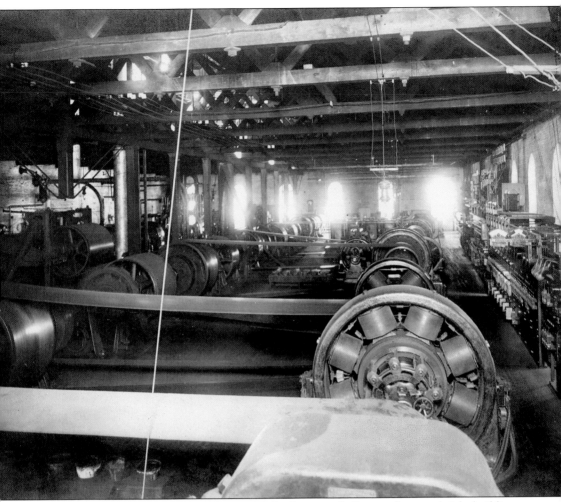

This was Savannah's first power station, with the initial Savannah gray brick building constructed on this site at Indian and Ann Streets in 1882. Called "The Works," it was a coal burning station, with a railroad spur and coal yard across River Street. Savannah was the first Southern city to have electric lighting. The 1894 pressed, fired brick extension that faces Indian Street has rectangular windows, as opposed to the arched windows of the older section facing River Street. A 1912 scene at the power station shows the switchboard and belted generators. In 1893, the first residence in Savannah received electric lighting. The name of the company changed to Edison in 1899. By the turn of the century, electricity powered Savannah trolleys and street and house lights. (Courtesy of the Georgia Historical Society, VM 1381, Album 1.)

This 1960s view of the Neil Blun complex with the water tower at the right shows the successive home of various woodworking firms from 1920 on, including a casket company and a cabinetry firm. Located at 3515 Montgomery Street at 52nd Street, the total area is some 125,000 square feet of industrial space, with approximately 64,000 square feet in use. (Courtesy of SCAD Campus Photography.)

The Neil Blun Company, a distributor of building materials and a cabinet factory, moved to the site in the 1950s. Shown here before its restoration by the college, which acquired it in 1998, the large open spaces on the 6.5-acre property provided a new home (called Montgomery Hall) for the digital arts departments at the college. Group Goetz of Washington acted as the principal architects for the renovation, which won a Historic Savannah Foundation award in 2003. (Courtesy of SCAD Campus Photography.)

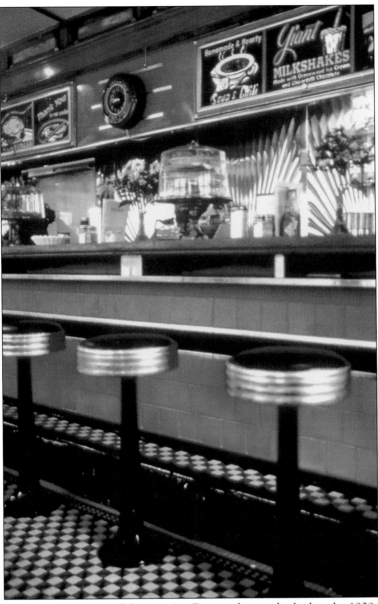

The gleaming geometric impact of the new Art Deco style is embodied in the 1939 Streamliner Diner, which was transported to Savannah and rehabilitated by the college in 1990. The vintage diner retains most of its original handcrafted features. They include the mauve marble counter tops, starburst patterned stainless steel behind the counter, stained glass transom windows, green ceramic tile beneath the windows and on the floor, and the six oak booths with more oak found above the windows and counters. The college was honored with an International Deco Defender Award in 1990 by the Art Deco Societies of America for the acquisition and rehabilitation of the Streamliner. The diner has 1,007 square feet and seats 36 customers. It is located in the Savannah Victorian District across from Henry Hall, permitting students and the public to experience a lost American dining tradition. (Courtesy of SCAD Campus Photography.)

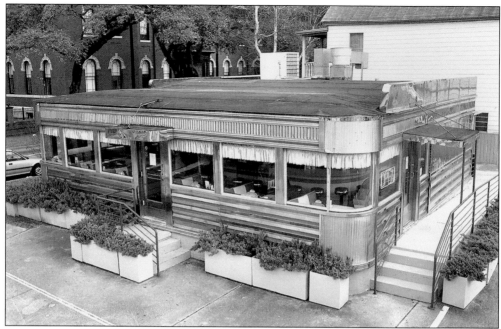

The 894-square-foot Bobbie's diner, manufactured in 1952 by Mountain View in Signac, New Jersey, is typical of the stainless stell diners introduced after World War II. Restored in 1989 after possibly being brought from Rhode Island, the classic exterior has porcelain enamel horizontal accents, rounded corners, large plate glass windows, and a projecting entry vestibule in the center of the facade. The diner's interior decor is accented by stainless steel and blue tile as well as white ceramic tile, with a large chrome entablature. Located across from Anderson Hall, the diner seats 41 people. (Courtesy of SCAD Campus Photography.)

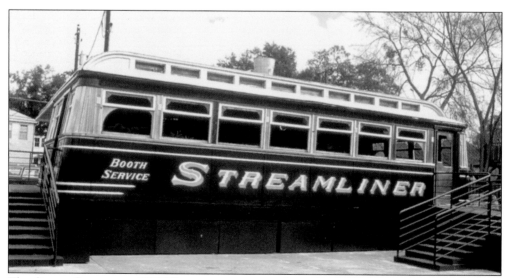

The diner reflects a rare 1939 Worcester semi-streamliner design (#751), manufactured by the Worcester Lunch Car Company, Massachusetts. It has a monitor roof (a closed barrel roof with clerestory windows), porcelain enamel panels on the exterior with Gothic lettering and typical canted ends. (Courtesy of SCAD Campus Photography.)

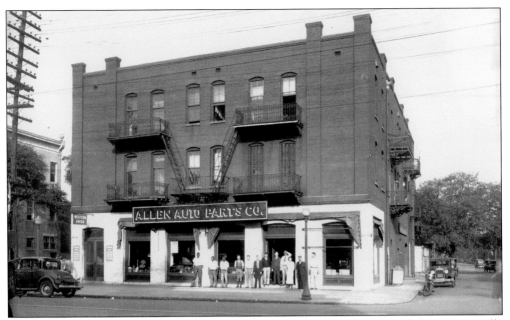

The three-story college bookstore Ex Libris (at 228 Martin Luther King, Jr.) was originally built by James C. Slater in 1904. A wholesale grocery was on the first and second floors, and apartments were on the third floor. The flat roof, simple brick façade (with the lower section painted), high storefront windows, and minimum ornamentation such as pilasters are typical. This c. 1936 photograph shows the exterior with fire escapes and awnings. (Courtesy of the Georgia Historical Society, Cordray-Foltz Collection.)

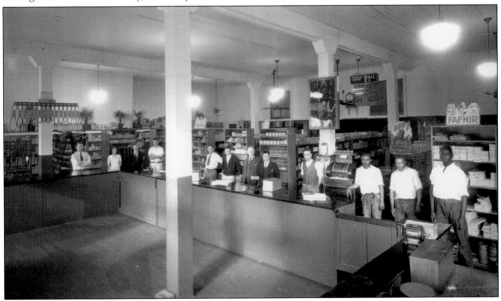

Numerous businesses have occupied the 29,060-square-foot structure, including the Allen Auto Parts store (where employees are shown here from the late 1930s), while later the Salvage and Sales Company was housed there. The large interior space with massive wood beams defines a simple, utilitarian layout. (Courtesy of the Georgia Historical Society, Cordray-Foltz Collection.)

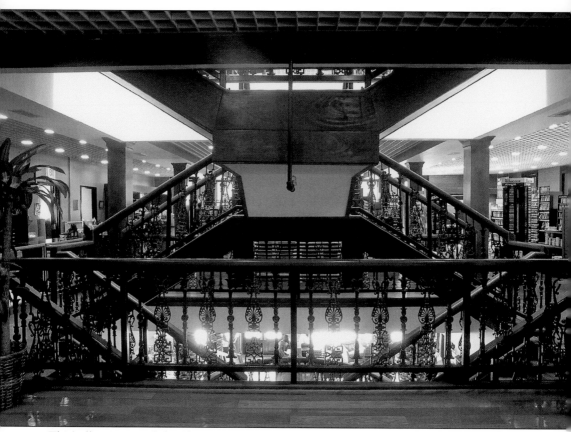

The college acquired the Slater property in 1991 and renovated it to house a bookstore, coffee bar, art supply store, and exhibition space in 1996. When acquired, the building had suffered from a fire that left a hole in the roof. The roof had partially collapsed and there had been standing water in the basement for years. Taking advantage of the generous space, the college added a central stairway, under which a coffee bar could be placed. This view shows some of the dramatic cast-iron and cherry wood design elements of the stairway. (Courtesy of SCAD Campus Photography.)

Another simple, two-story, commercial brick building is the c. 1945 Alexander Grocery Company, located at 668 Indian Street. Today called Alexander Hall, the original site took advantage of a Central of Georgia Railroad spur. This view, possibly from the late 1940s, shows men unloading a truck on the canopied loading dock across the entire façade. The original Talmadge Bridge of 1954 has not yet been constructed. (Courtesy of SCAD Campus Photography.)

The 48,000-square-foot space had eight skylights, which still exist. Renovated in 1996 as studio and exhibition space, the large simple interior permitted new spatial configurations. (Courtesy of SCAD Campus Photography.)

(*above, left*) Many turn-of-the-century Savannah buildings have ceilings of pressed tin, as seen in the 1926 Bergen Hall, which also has an exposed timber structure. Located at 101 Martin Luther King, Jr., Boulevard, the five-story loft building was designed by Cletus Bergen with an award-winning partial renovation in the 1980s by SCAD architecture alumnus Barry Rentzel. (Courtesy of SCAD Campus Photography.)

(*above, right*) The architect Cletus Bergen and his son William designed many of the buildings in Savannah from 1907 to 1975. Among Bergen's SCAD buildings are an auto repair store known as Orleans Hall, and this one which bears his name. (Courtesy of the Bergen family.)

This 1938 photograph was taken when its original owner Slotin & Co. Wholesale Dry Goods still occupied Bergen Hall (1926–1964). There are large industrial sash windows, an exposed timber structure, interior brick walls, and ornamental cast-stone details. The college purchased the 41,150-square-foot Atrium Building in 1990 and completed the renovation. (Courtesy of the Georgia Historical Society, Cordray-Foltz Collection.)

A glamorous night view of the Weis Theater in 1946, the year it opened, captures the excitement of the Savannah theater district. The architect of the Art Moderne structure was the Tucker and Howell firm from Atlanta, who designed it for Mr. and Mrs. Fred G. Weis. Tucker and Howell were the only Georgia architects representing the International style in the 1932 exhibition curated by Philip Johnson and Henry Russell Hitchcock for the Museum of Modern Art. The partners—McKendree Tucker (1896–1972), who trained at Georgia Tech, and Albert Howell (1904–1974), the son of *Atlanta Constitution* editor Clark Howell—developed a specialty in modern theater architecture in Georgia, designing at least eight other theaters besides the Weis. (Courtesy of the Georgia Historical Society, Cordray-Foltz Collection.)

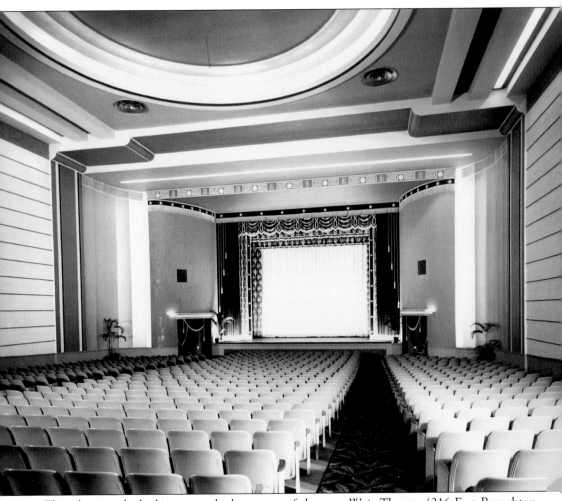

This photograph, looking towards the screen of the new Weis Theater (216 East Broughton Street), shows the sleek lines and abstract harmony. Built during World War II, the Weis Theater had the War Production Board overseeing all construction. The theater seated 1,200 patrons and could accommodate both motion pictures and theatrical performances. (Courtesy of the Georgia Historical Society, Cordray-Foltz Collection.)

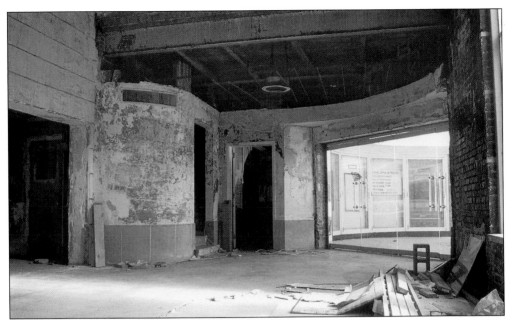

The theater's atrium may be seen here before its restoration. The Weis Theater closed in 1980, and it stood abandoned for years. It was acquired by the Savannah College of Art and Design in 1989. The rounded forms and flowing space show an area rich with possibilities despite its extensive deterioration. (Courtesy of SCAD Campus Photography.)

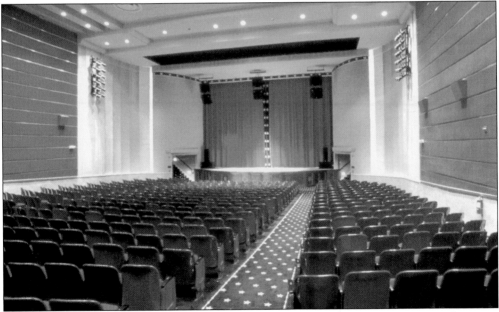

The theater reopened as the college's Trustees Theater on May 9, 1998, with a performance by singer Tony Bennett. The current interior view reflects the updated technology with state-of-the-art digital surround sound for film and video production and with dramatic recessed lighting. The overhead medallion has been re-gilded, the seats were recovered with fabric from the original company, and other interior details such as rope lighting have been added. (Courtesy of SCAD Campus Photography.)

Upon completion of the renovation in 1998, the theater marquee lights came back on. Used as a performance space, for lectures and large meetings, and for other public events as well as for films, the 1,100-seat theater (about 12,000 square feet) has gained a new life, helping to revitalize Broughton Street's east end. It is found on the north side of the street across from the college's Jen Library. Trustees Theater is a significant landmark in streamlined Moderne architecture for the Southeast, an excellent example of Tucker and Howell design at its finest. (Courtesy of SCAD Campus Photography.)

The Downtowner Motor Inn at 201 West Oglethorpe Avenue, shown here, was built in 1966 and later became the Civic Center Ramada Inn. The college acquired the six-story structure in 1989 and renovated it in 1990 to serve as a 90,250-square-foot residence hall. Other former motels have similarly been converted. (Courtesy of the Georgia Historical Society.)

The current view of the residence hall suggests that it still works well for its situation along one of Savannah's historic tree-lined avenues. Presently named Oglethorpe House for Oglethorpe Avenue, its location across from the civic center near one of the gateway routes into Savannah's downtown historic district retains an accessible and effective layout. The motel's swimming pool was replaced with an outdoor dining area during renovations in 2002. (Courtesy of SCAD Campus Photography.)

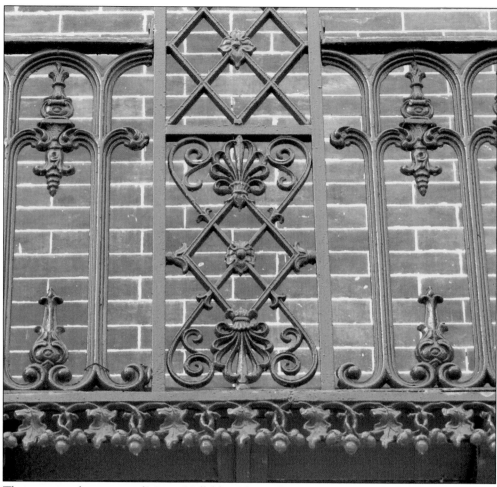

The cast-iron decoration of Morris Hall (the Alexander A. Smets House) expresses some of the richness of the iron tradition in Savannah. Providing a screen between the house windows and the street as well as a canopied balcony area, the functional aspects are complemented by the decorative scrolls, foliate and acorn patterns, and intricate linear design. (Courtesy of SCAD Campus Photography.)

Six

From Gracious Homes to Academic Elegance
Reinterpreting Private Spaces

While the larger institutional and public structures of Savannah presented a unique potential for adaptive campus re-use, some of the college's most charming spaces began as residences. They are intimate in scale, and they blend into their neighborhoods rather than dominating them as anchor buildings. To preserve this sense of private, cherished space, the college has kept the functions of converted dwellings more limited, using them as private offices, guest houses, or student centers for smaller groups. (Courtesy of SCAD Campus Photography.)

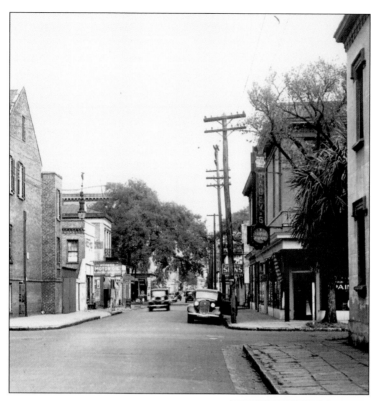

The earliest residence in use as a college building is the 1841 John B. Gallie House, now called Harris Hall (26 West Harris Street). It was designed by John S. Norris with projecting cornices and dentils beneath a narrow roof parapet. By the time of this 1934 Whitaker Street view by George R. Foltz, Harris Hall (seen at the right at the northeast corner of the intersection) had a commercial entrance, added in 1913 (Courtesy of the Georgia Historical Society, Cordray-Foltz Collection.)

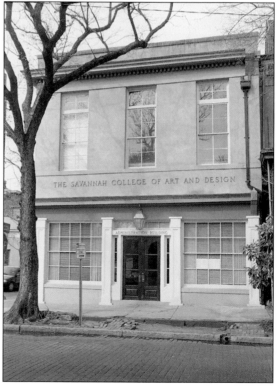

The original owner of the two-story masonry and brick structure house (6,000 square feet and acquired by the college around 1983) was Maj. John B. Gallie (c. 1806–1863), the commander of Fort McAllister who was killed in action. An immigrant from Scotland, Gallie was a wealthy businessman, a director of Central Railroad, partner in the J.R. Wilder and Gallie steamship firm, leader of the Chatham Artillery, and an 1855 candidate for public office as a representative of the Know-Nothing Party. (Courtesy of SCAD Campus Photography.)

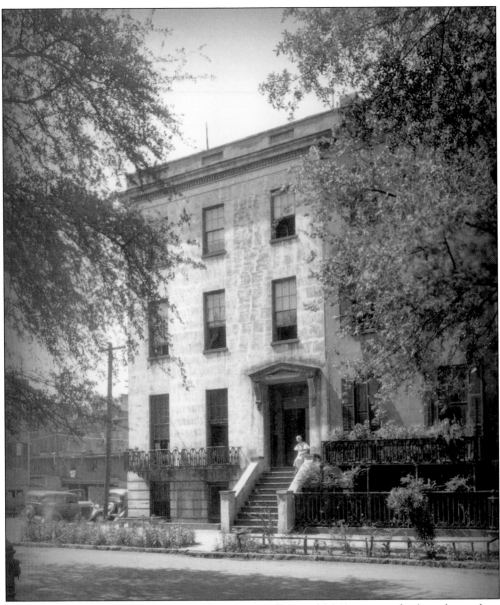

This stately four-story Greek revival–style townhouse (6,240 square feet) is located at 201 West Charlton Street facing Pulaski Square. It was built in 1854 for Mrs. Celia Moses Solomon, whose husband, Abraham Alexander Solomon, founded Solomon's Drug Company. She also had the adjacent townhouse constructed. A carriage house is found at the rear of the building, facing Barnard Street. Charlton Hall was rehabilitated in 1988 to serve as an administration building. This view from about 1930 of the house illustrates its restrained elegance and sense of proportion. A projecting pediment over the door is supported by consoles, and stone steps rise to the recessed entrance. A narrow cornice with dentils defines the upper edge of the building, which is also topped by a simple parapet. The basement level is articulated with the effect of banded rustication. Charlton Hall's position on an important intersection (Barnard and Charlton Streets) gives it a special prominence. (Courtesy of the Georgia Historical Society, Cordray-Foltz Collection.)

The cast-iron balcony at Charlton Hall adds a touch of delicate grace with a linear tracery that both contrasts and complements the simplicity of the Greek revival façade. The present cast-iron stair rail has beautiful caged end posts. (Courtesy of SCAD Campus Photography.)

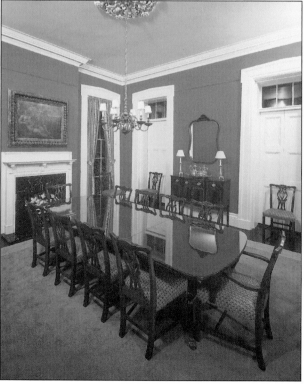

The interior of Charlton Hall captures the gracious style of the mid-19th century. Here a view of the second floor's former dining room with its high ceiling and fireplace shows its successful re-use as a conference room. Sliding pocket doors separated the dining room from the adjacent parlor. (Courtesy of SCAD Campus Photography.)

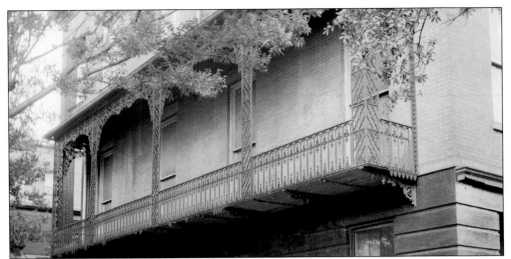

Another example of beautiful cast-iron work is the balcony of the Alexander A. Smets House (presently Morris Hall) shown here from the west in 1936. Built in 1853 and occasionally attributed to John S. Norris, the stucco structure at 2–4 East Jones Street has 8,262 square feet of space excluding the carriage house. The balcony marks the boundary between the banded stucco rustication of the lower floor and the brick façade of the two upper floors, paralleling the line of the heavy cornice and the standing seam metal roof. (Courtesy of L.D. Andrew, photographer, and Library of Congress, Prints and Photographs Division, Historic American Engineering Record, GA, 26-SAV, 31-1.)

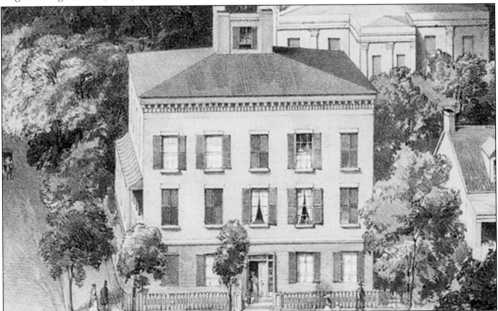

Shown here c. 1856 shortly after its construction, the house was built for Alexander Augustus Smets, an erudite immigrant from Nantes, France, displaced by the French Revolution, who was the director of the Bank of the State of Georgia. The lithograph by Charles Parsons is after a painting by John William Hill from a series of city views printed by Endicott & Co. (Courtesy of I.N. Phelps Stokes Collection, Miriam and Ira D. Wallach Division of Art, Prints and Photographs, The New York Public Library, Astor, Lenox and Tillden Foundations.

This *c.* 1910 view of Morris Hall, found at the intersection of Bull and Jones Streets, suggests its elegant proportions. There are casement windows with stone lintels and a cornice with heavy brickwork and dentils. Further north may be seen Poetter Hall and further still the DeSoto Hotel. In an 1888 article in *Harper's New Monthly Magazine*, the writer notes, "At the corner of Jones and Bull streets is a spacious and costly brick building, formerly the residence of the

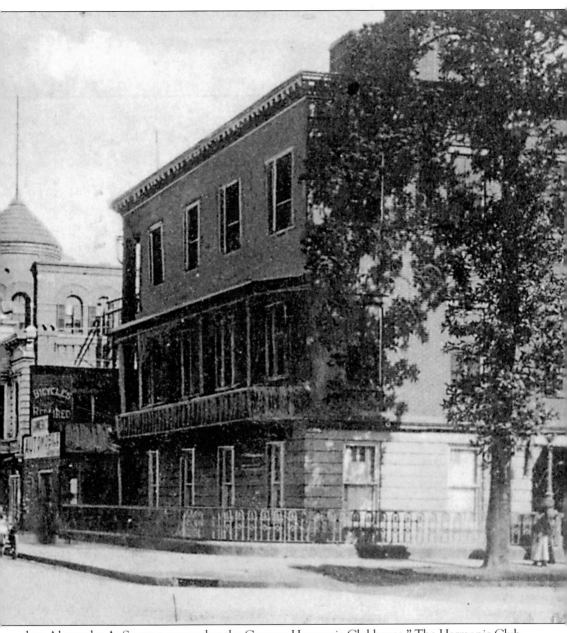

late Alexander A. Smets, now used as the German Harmonie Clubhouse." The Harmonie Club (one of the two most prominent social clubs in Savannah) purchased the building in 1883. In 1892, Preston designed plans (never built) for the Harmonie Club that would apparently have linked the Smets House with the armory. (Courtesy of the Georgia Historical Society, GHS Postcard Collection.)

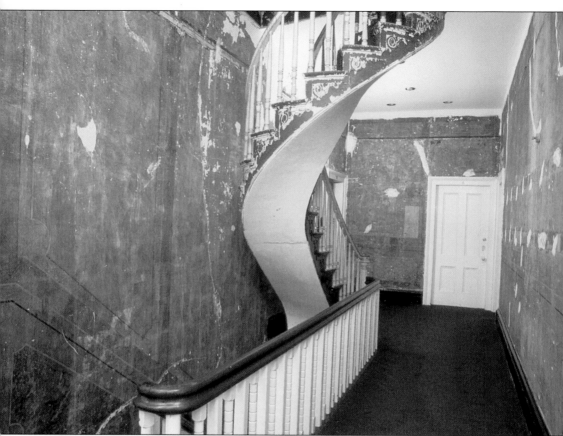

This view of the interior of Morris Hall before restoration shows one of its most significant architectural features—a free-standing spiral staircase leading up to a cupola and trompe l'oeil wall paintings. The interior, which also has elaborate plasterwork, had not been a private residence for some time. In the 1850s, the Smets House was one of Savannah's literary centers. The Smets Collection comprised an extensive library as well as artworks such as Hogarth prints and illuminated medieval manuscripts. The *Southern Literary Messenger* described the collection's impact: "The first emotion on entering and casting the eye around upon the magnificent display of the ample shelves, is that of surprise, that the visitor had not before heard of so extensive and luxurious a collection." The remarkable collection was auctioned off after the Civil War. (Courtesy of SCAD Campus Photography.)

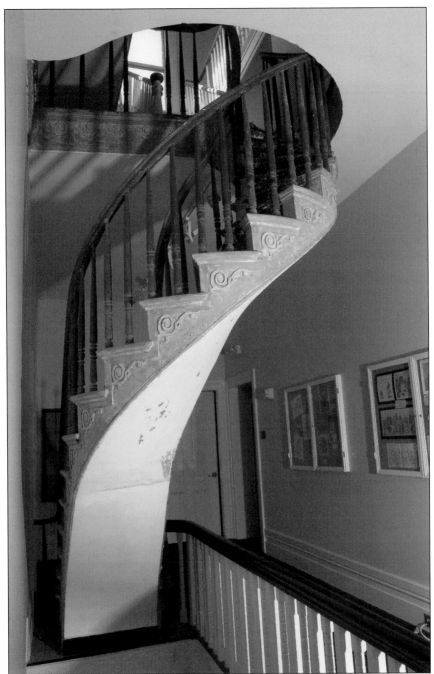

After the Harmonie Club moved out in the 1950s, a succession of tenants occupied the upper floors with commercial space on the ground floor. When the college acquired the five-bay Italianate building in 1990, it began to restore some of the unique features, such as the spiral stairway. It is seen here after restoration. This is the only spiral stairway of its type in Savannah. It is of heart pine construction with delicate pine scrollwork and tight-grained mahogany banisters and cap rail. The original plaster is found on the back side. A wall niche is located near the stairway. (Courtesy of SCAD Campus Photography.)

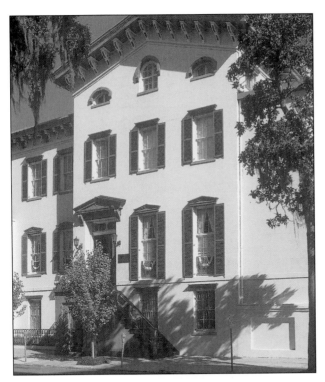

Keys Hall (516 Abercorn Street), shown here in a contemporary view, was built in 1870 for Algernon Hartridge, a captain of the DeKalb riflemen. The four-story Italianate residence is constructed of Savannah gray brick with scored stucco, angled metal pediments over the windows, an ornate Greek revival pediment over the portal, and deep eaves supported by decorative wooden brackets. (Courtesy of SCAD Campus Photography.)

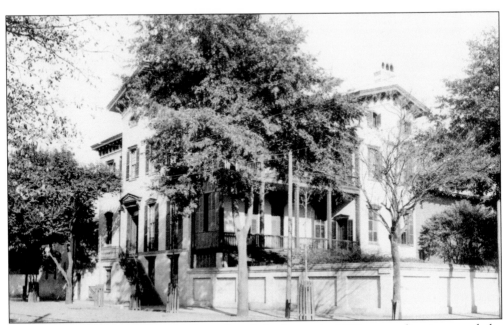

Alexander R. Lawton (1818–1896) purchased the house in 1890, expanding it toward the north as seen in this c. 1895 view. A brigadier general in the Confederate army, Lawton was both a founder and a president of the American Bar Association as well as minister to Austria-Hungary. (Reproduced from Charles H. Holmstead, Artwork of Savannah, Chicago: W.H. Parish, 1893, Courtesy of the Georgia Historical Society.)

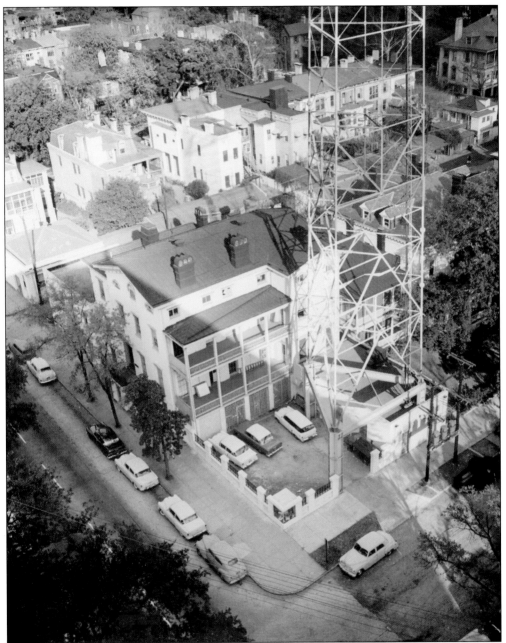

In 1939, Keys Hall (about 18,000 square feet with all additions) was purchased by the Savannah Broadcasting Company to serve as the offices and studios of the local CBS affiliate, WTOC. This 1954 aerial view of Keys Hall shows the building immediately after the WTOC tower was installed. The balconies are still visible, but they were walled in at some later point. Sections of the carriage house were incorporated into the transmission studio on the north elevation. In 1995, it was acquired by the college and rehabilitated in 1998 to serve as an office building. (Courtesy of the Georgia State Archives, Vanishing Georgia Collection.)

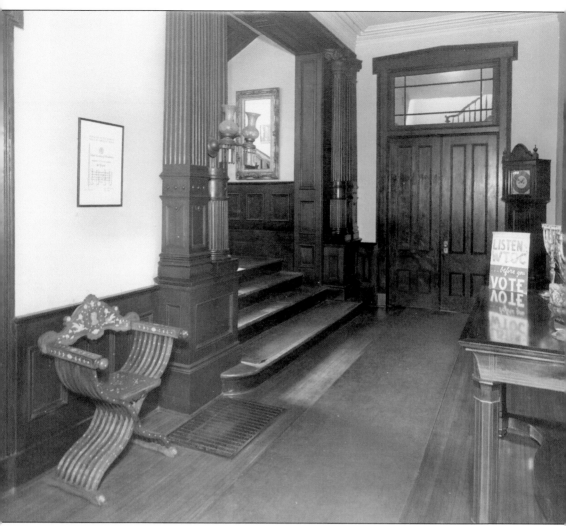

Bridging the Lawton expansion to the north is a grand lateral stairway between the old and the new sections. This view of the atrium and staircase is from 1940 when WTOC owned the building. The wainscoting and doors are of heart pine, while the columns, base, and accoutrements are of pine, mahogany, and walnut. The detail carries through to the upper level. The floor is a narrow one-inch oak over the original pine floors. The original walls and crown moldings (prior to WTOC) had a very detailed palette and included a gold leaf finish on the picture rail. (Courtesy of the Georgia Historical Society, Cordray-Foltz Collection, VM 1360:9:1.)

The Hone House (now called Clinard Hall, 618 Drayton Street) is located across from the eastern border of Forsyth Park. The three-story Italianate stucco townhouse (4,647 square feet) was built in 1872 for William Hone, a wine importer. Its façade features prominent quoining, arched stone lintels, and a bracketed cornice. The south elevation has a two-story Charleston side porch with graceful saw-work balustrades. Acquired in 2002, the building was rehabilitated to serve as offices. (Courtesy of SCAD Campus Photography.)

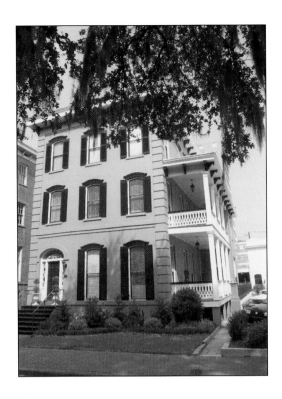

The Clinard Hall portal is Greek revival in style with sidelights and a fanlight. Its owner, William Hone (1819–1893), was first a ship's captain and, after his arrival in Savannah, a ship chandler. He was a blockade-runner during the Civil War and was twice captured and escaped. He organized the Savannah Soap Company and was an original member of the Savannah Yacht Club. (Courtesy of SCAD Campus Photography.)

Like Clinard Hall, the Thomas B. Butler House (now Lai Wa Hall) is a side porch construction. This view from Lai Wa Hall looking west towards Forsyth Park, laid out in 1851, shows the appeal for owners in this newly established neighborhood. The covered veranda has Corinthian columns and Romanesque arches. (Courtesy of SCAD Campus Photography.)

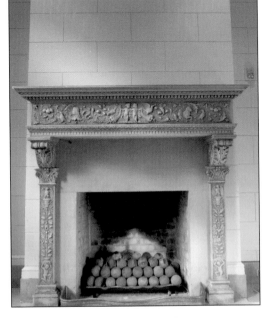

The cast-stone fireplace ensemble in the atrium of Lai Wa Hall reflects Renaissance revival motifs with putti, rinceaux, and classical detailing. The 4,647-square-foot interior also features decorative window moldings with anthemion motifs. (Courtesy of SCAD Campus Photography.)

Lai Wa Hall was built in 1877. A classical revival–style residence located across from Forsyth Park (622 Drayton Street), the building was acquired by the college in 2002 and its renovation awarded a Historic Savannah Foundation Award in 2003. It is shown here before rehabilitation. The two-story-over-basement brick structure was once the home of Thomas M. Butler, a financier and cotton broker. The building was renovated in 1924 and previously housed attorney offices. The symmetrical façade features Palladian windows, Ionic columns framing the main entrance, and other classical elements. Interior highlights include a marble foyer with a cast-iron staircase, 13-foot coffered ceilings, wood inlay floors, and leaded glass windows in the dining room, now a conference room with French doors opening to the veranda. (Courtesy of SCAD Campus Photography.)

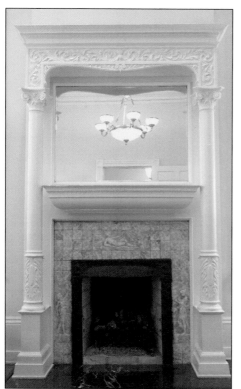

In 1896, John F. Lubs (died 1935) built a house at the intersection of Habersham and Liberty Streets that would serve as a combined corner grocery and a private residence. The two-story red brick structure (now called Casey House, approximately 10,000 square feet, 318–320 Liberty Street) reflected typical Victorian domestic architecture with several components that could be ordered through a catalogue, this fireplace being an example. (Courtesy of SCAD Campus Photography.)

The front parlor at Casey House is shown below after restoration. The restoration received an Excellence in Rehabilitation award in 1997 from the Georgia Trust for Historic Preservation. The building currently serves as a college bed and breakfast. Most recently, students directed by Prof. Yves Paquette designed a sculpted brick wall behind the fountain in the western side garden. (Courtesy of Deborah Whitlaw, photographer.)

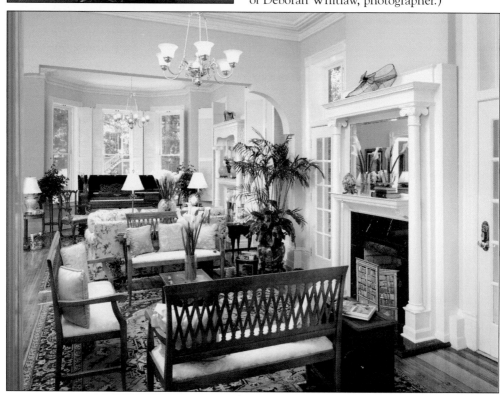

In 1895, the local newspaper noted "J.F. Lubs new store and dwelling at Liberty and Habersham Streets . . . are among the more important residence improvements in brick." The ornate brickwork of the Queen Anne revival–style Casey House includes a roof parapet and red and yellow brick arches above the second-floor windows which are fronted on Liberty Street by a wrought iron balcony. This 1940s view shows a commercial establishment at the back attached to the earlier carriage house and with the Chatham County jail on the far right. (Courtesy of the Georgia Historical Society, Cordray-Foltz Collection.)

Casey House was acquired in 1993 from Tony Yatro, who had used the corner store as a confectionery for many years. It had been abandoned since 1972 and before its renovation was listed among the Historic Savannah Foundation's top 10 most endangered buildings. Lubs around 1895 had applied for permission to install the bay window (shown here before restoration), located beneath the southwest turret with its octagonal metal roof. (Courtesy of SCAD Campus Photography.)

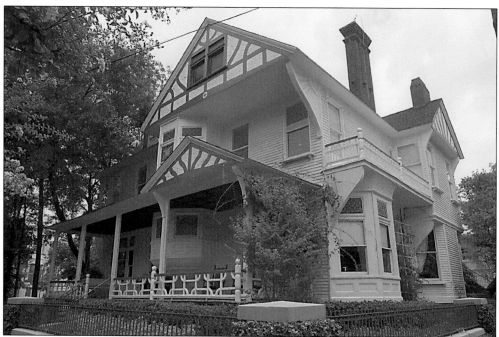

Located at 118 West Hall Street, the Jesse Parker Williams House (currently called Smithfield Cottage) has recently been restored. The house contains all of its original Victorian design elements, including stained-glass windows, hand manipulated polychrome plasterwork on the ceilings, and mantels with pressed composition inlay and wood paneling. Adorning the dining room's upper wall is a floral and fruit frieze of plaster and seashells. (Courtesy of SCAD Campus Photography.)

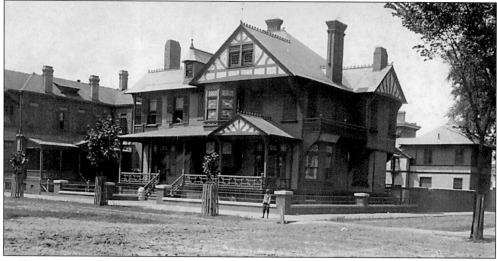

Williams commissioned Alfred S. Eichberg and Calvin Fay to design his house, which was built in 1888. This view from about 1900 shows the structure when it was new. The dominant features on the south façade are the projecting paired, timbered gables and the full-length porch roof. Vertical elements include dormers and chimneys. The asymmetry is typical of the Queen Anne style. In 1932, the house was the first in Georgia to have central air conditioning installed. (Courtesy of the Georgia Historical Society, Saussy Family Papers # 1276:6:48.)

The Smithfield Cottage plan (4,459 square feet) corresponds with a type popularized in publications like *Shoppell's Modern Houses* of 1887, where clients could purchase an entire set of readymade architectural plans according to their needs and resources. Design No. 506 shows a similar house. Shoppell frequently advertised in Savannah. (Reproduced from *Shoppell's Modern Houses*, Antiquity Reprints: Rockville Centre, NY, 1978.)

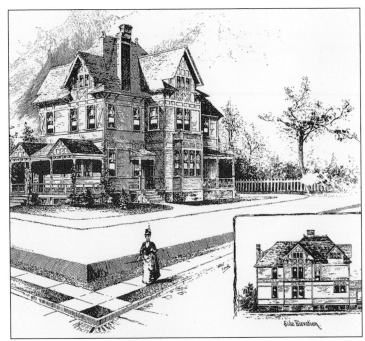

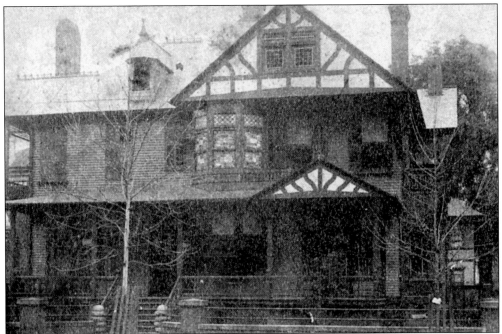

This *c.* 1900 view shows Smithfield Cottage's front elevation with decorative half timering. J.P. Williams was educated at the Franklin Military Institute and the University of Virginia, then served as a captain in the North Carolina Infantry. He arrived in Savannah in 1879 to work in the naval stores and as a cotton factor. Williams added a grocery business to his naval stores commission house, then acquired interests in the timber and railroad industries, beginning construction of the Georgia, Florida and Alabama Railroad. (Courtesy of the Georgia State Archives, Vanishing Georgia Collection.)

MANTEL.

2127

Length of Shelf	5 feet.
Width of Opening	2 " 11½ inches.
Height of Opening	2 " 11¼ "
By moving back Side Linings, width of Opening may be varied up to	3 " 6 "

WRITE FOR PRICES.

With the advent of manufacturers and catalogue sales of individual architectural elements, both the architect and the homeowner could select according to their taste. An example is seen in this 1893 catalogue page with fireplaces. (Reproduced from *Turn-of-the-Century Doors, Windows and Decorative Millwork: The Mulliner Catalog of 1893*, Dover Publications: New York, 1995.)

The fireplace at Smithfield Cottage has an elaborate mirrored overmantel with storage cabinets and intricate woodwork, while the hearth has a tile inlay and an arched brass grill. The pristine condition of the cottage is in part due to the care given by the previous owner, antiques dealer Arthur Smith, who donated part of the purchase price when he sold it to SCAD in 2004. (Courtesy of SCAD Campus Photography.)

DESIGNS FOR STAIRS.

1551 1552

1553 *WRITE FOR PRICES.* 1554

Catalogue suppliers also dealt with multiple architectural elements such as stairways, as seen in this example with newel posts and balusters. (Reproduced from *Turn-of-the-Century Doors, Windows and Decorative Millwork: The Mulliner Catalog of 1893*, Dover Publications: New York, 1995.)

Many of the original stamped, decorative metal hinges, knobs, and escutcheon plates are intact. An example of the historic hardware is this doorknob and plate. (Courtesy of SCAD Campus Photography.)

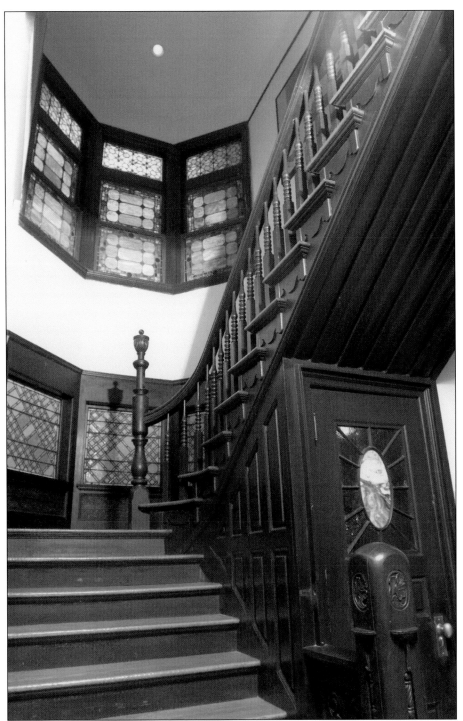

The stairway at Smithfield Cottage has turned balusters, a carved newel post, and other typical Victorian carpentry elements. A protruding bay window over the landing has colorful stained glass, in keeping with domestic architecture in the Queen Anne style. (Courtesy of SCAD Campus Photography.)

Alfred S. Eichberg and Calvin Fay were in partnership from 1881 to 1889 and did many projects in Savannah. Here is their architectural firm advertisement from the *Savannah Morning News* of July 17, 1887, about the time they were working on Eichberg Hall and Smithfield Cottage. (Courtesy of the Georgia Historical Society.)

APPENDIX

Profiles of Principal 19th-century Architects
of Savannah College of Art and Design Buildings

EICHBERG, ALFRED S. Eichberg, along with William Gibbons Preston, was responsible for designing influential examples of the Richardsonian Romanesque style in Savannah. Born in 1859 in New York but raised in Atlanta, Eichberg went to Germany in 1876 for training in Stuttgart or Heidelberg, following two years at the Atlanta architectural offices of William H. Parkins. He and Calvin Fay were in partnership from 1881 to 1889, with their first joint project some structures for the 1881 International Cotton Exposition in Atlanta.

Their first Savannah project was the construction of the Telfair Hospital for Women (1886). They established a permanent office on Bull Street in Savannah in 1887. Fay and Eichberg designed a major office building for the Central of Georgia Railroad (1888), called the Red Building, now a SCAD property. Among Fay and Eichberg's residential designs was that for J.P. Williams on West Hall Street, also owned by SCAD. During his period in Savannah, Eichberg had the largest number of architectural projects, doing more than $300,000 worth of business in 1889.

In 1896, Eichberg entered into a partnership with Hyman Witcover. Two years later in 1898, Eichberg left Savannah, ultimately returning to Atlanta to run his family's manufacturing business (Atlanta Machine Works). He played a prominent role in social affairs in Atlanta, serving as the president of the Standard Club and supporting the opera and other causes. Eichberg had been a charter signatory for the establishment of Savannah's Scottish Rite Temple. In 1915 in Washington, the then-retired Eichberg was elected to the 33rd degree of Masonry, one of the highest levels. He died in Atlanta in May 1921.

FAY, CALVIN. Born in 1819 in Buffalo, New York, Fay's first project was to design the Gothic revival–style St. John's Episcopal Church in Savannah with architect Calvin Otis in 1851–1853. He was a Confederate artillery captain with his own company and, after the Civil War, became a building inspector in Atlanta until 1875. He was elected to the 33rd degree of Masonry and was a Knight Templar. He maintained an active architectural practice throughout Georgia and was especially known for his Italianate designs. In partnership with Eichberg, he designed a number of civic buildings in Atlanta, including the Atlanta Chamber of Commerce, as well as the state mental hospital at Milledgeville and numerous residences. He died in 1890.

MCDONALD, HARRY P. AND KENNETH. The McDonald brothers had an architectural firm in Louisville, Kentucky. Harry P. McDonald (1848–1904) had studied civil engineering at Washington College (now Washington and Lee University) in Virginia. He began as a railroad construction engineer but opened an architecture practice with his brother Kenneth McDonald (1847–1904) in 1878. Kenneth also graduated from Washington College in 1870. In 1880, the brothers settled in Louisville, Kentucky, using the firm name of McDonald Brothers. Among the brothers' more important public commissions were the original building for the University of Kentucky (1882) and Union Depot of 1891 (Central Station), St. Paul's Episcopal Church in New Orleans, and portions of the Kansas State Capitol Building (1903).

NORRIS, JOHN S. Norris was born in 1803 in Tarrytown, New York, and began as a bricklayer. After various public projects in Wilmington, North Carolina, the architect arrived in Savannah to work on the U.S. Customs House and stayed from 1846 until 1860. He became one of the most respected architects in the city, credited with more than 20 structures. The Savannah architect DeWitt Bruyn became a partner in 1860 Bruyn, a Confederate infantry captain and later a member of the Société Centrale des Architectes of Belgium, worked in Atlanta and in Savannah with Calvin Fay, and was still active in 1891. By 1861, Norris had returned to New York.

Among Norris's designs are the Old Customs House in Wilmington, North Carolina (1843), the Savannah Customs House (1852), the Andrew Low House (1847), the Gothic revival Green-Meldrim House (1853), the 1854 Gothic-style First Presbyterian Church (destroyed), the Massie School of 1856, and the Italianate Mercer House (1860), as well as the Abrahams House, a home for indigent widows (1858), currently serving as a SCAD academic building.

NORRMAN, GOTTFRID (GODFREY) LEONARD. Norrman was born in Sweden in 1848 and died in Atlanta, Georgia, in 1909. He was educated at the University of Copenhagen and in Germany. He traveled extensively in Europe, Central America, and in Texas, finally going to Atlanta at the time of the 1895 Cotton States Exhibition, for which he designed some of the largest buildings. Norrman was elected an associate of the American Institute of Architects in 1885 and a fellow in 1897. He helped found the Southern Chapter of the American Institute of Architects in 1892 and the Atlanta Chapter in 1906, becoming a vice president of the latter.

Among his principal buildings in Atlanta were the Silvey Building (now demolished), the Peachtree Street First Baptist Church (also demolished), the Christian Science Church, and many residences. He designed a number of buildings across the southeast, including the Windsor Hotel in Americus, Georgia.

His buildings in Savannah include the neoclassical mansion built for L. McNeil on Whitaker Street, the steel-framed Citizens Bank of Savannah building (a SCAD property), and some of the public school buildings (Henry Street School, Anderson Street School, and Barnard Street School, all now housing SCAD studio and academic departments).

PRESTON, WILLIAM GIBBONS. Preston (1842–1910) was a Boston architect noted for his use of the Romanesque revival style. He studied at Harvard and later at the Ecôle des Beaux-Arts in Paris and then joined his father's architectural practice in 1861. He was elected an associate of the American Institute of Architects in 1870 and a fellow in 1884. His most significant buildings include the Rogers Building (now demolished) of the Massachusetts Institute of Technology, the Cadet Armory on Columbus Avenue, the New England Museum of Natural History, and educational facilities such as the Boston University School of Law and the State Industrial School for Girls.

Preston was invited to Savannah by George Baldwin, the first president of the Savannah Electric and Power Company, who had met Preston at the Massachusetts Institute of Technology and secured the commission of the Savannah courthouse for him. His Savannah commissions included the Savannah Cotton Exchange (1886), the Chatham County Courthouse (1889), the Baldwin residence, the DeSoto Hotel (1890), and the Savannah Volunteer Guards Armory (1892), SCAD's flagship building.

SCHWAAB, AUGUSTUS. A German-American architect and civil engineer, Schwaab was born about 1821 and died in 1899. Initially Schwaab was listed in records as a surveyor, then as a draughtsman, and by the 1870s, was advertising as an architect and civil engineer. In 1865, Schwaab was appointed the chief engineer of Central Railroad of Georgia. He went into partnership with Martin Philip Muller in 1870 with an office on Bay Street.

Schwaab designed the Georgia Academy for the Blind (1859) and the C.S. Armory (1863) in Macon, Georgia. Working in Savannah for some 50 years, Schwaab designed the now

demolished City Market on Ellis Square, as well as a number of Central of Georgia and other railway buildings, including the passenger terminal and the North Viaduct (today a SCAD pedestrian walkway). He was active in the Georgia Historical Society, where he was elected a curator in 1877, in the SchützenVerein gun club, and in the Gejsel-Schait Rifle Company.

WALLIN, HENRIK. A Swedish architect who had studied in France and Italy, Wallin (1873–1936) came to the United States to visit his sisters in St. Paul, Minnesota. He was associated with Henry Bacon on the Astor Hotel project in New York and went to Savannah to work with Hyman Witcover on the Germania/Liberty Bank (demolished). He later had a firm, Wallin & Young (Edwin Y. Young, born in New York c. 1878), until the early 1920s, then partnered with Arthur F. Comer.

Wallin designed a complex of buildings on Ossabaw Island near Savannah as well as the first YMCA building (1910), the Bull Street Baptist Church, the Hull Memorial Presbyterian Church, the Oliver Apartments, a cigar factory, and the George Ferguson Armstrong mansion (1917–1920) as well as a school building on East 37th Street, presently a SCAD academic building. He became the first president of the South Georgia Chapter of the American Institute of Architects.

WITCOVER, HYMAN WALLACE. Witcover was born in 1871 in Darlington, South Carolina, and died there in 1936. He practiced architecture in Savannah, Georgia, beginning as a draughtsman for Alfred Eichberg in the late 1880s and later becoming a partner in the Eichberg firm. He opened a Savannah office in 1906 and was active in the city for a quarter of a century. He became a member of the American Institute of Architects after 1916. Witcover was the first president of the Savannah Society of Architects and a member of the Georgia State Board of Architect Examiners. He was elected to the 33rd Degree in Masonry and was elected the secretary-general of the Supreme Council of Scottish Rite in Charleston, South Carolina, in 1923. He also served as the sovereign grand inspector general in Georgia and South Carolina.

He designed buildings throughout the South. Among his notable Savannah structures are the City Hall (1904), the Savannah Public Library on Bull Street (1914), the Scottish Rite Temple, the Liberty Bank building, and the synagogue for the Congregation B'nai B'rith Jacob, which later became the St. Andrew's Independent Episcopal Church and is now a SCAD building. He also added the wings to the Henry Street School, also a SCAD structure.

SUGGESTED READING

Adler, Lee and Emma. *Savannah Renaissance*. Charleston: Wyrick & Company, 2003.

Craig, Robert M. "Tucker and Howell." *New Georgia Encyclopedia*. http://www.georgiaencyclopedia.org

Funderburke, Richard D. "Fay and Eichberg" and "G.L. Norrman (1848–1909)." *New Georgia Encyclopedia*. http://www.georgiaencyclopedia.org.

Kelley, David. *Building Savannah*. Charleston: Arcadia Publishing, 2000.

Lane, Mills B. *Savannah Revisited: History and Architecture*. 5th ed. Savannah: Beehive Press, 2003.

Toledano, Roulhac. *The National Trust Guide to Savannah: Architectural and Cultural Treasures*. New York: John Wiley and Sons, 1997.

INDEX

Abrahams, Dorothea, 66
Abrahams Home, 66–67
Alexander Hall, 93
Anderson Street School, 51, 55-58
Anderson Hall, 55–57
Barnard Street School, 51, 58–61
Beach Institute, 7, 51
Bergen, Cletus, 69, 84, 94
Bergen Hall, 94
Blun, Neil, 88
B'nai B'rith Jacob Synagogue, 77–78
Bobbie's Diner, 90
Bogardus, Abraham, 36
Butler, Thomas B., 114–115
Brush Electric Light & Power
 Company, 86–87
Bruyn, DeWitt, 68
Casey House, 116–117
Central of Georgia Railroad, 8, 9, 16,
 26, 27–50, 93, 102
Charlton Hall, 103–104
Chatham County Jail, 68–70, 117
Citizens Bank Building, 71–75
Clinard Hall, 113–114
Customs House, 67
Cuyler, Richard Randolph, 36
DeSoto Hotel, 7, 24, 106
Down Freight Warehouse, 28, 37–38,
 42–44
Downtowner Motor Inn, 99
Eichberg, Alfred S., 26, 44, 118, 124
Eichberg Hall, 26, 41, 43–49
Exchange Bank, 64, 75–76
Ex Libris, 91–92
Fay, Calvin, 26, 44, 118, 124
Federated Department Stores, 80, 83
First Church, 67
Gallie House, John B., 102
Gordon, Peter, 6
Gordon, William, 27, 36
Gray Building, 28–30
Group Goetz, 88
Habersham Hall, 68–70
Hamilton Hall, 86–87
Hamilton, Samuel P., 86
Harmonie Club, 106–107, 109
Harris Hall, 102
Hartridge, Algernon, 110
Henry Hall, 50–54, 89

Henry Street School, 50–54
Hone, William, 113
Howell, Albert, 95, 98
Indian Street Power Station, 86
Jen, Jim and Lancy, 80, 83
Jen Library, 80–85, 98
Jewish Educational Alliance, 79
Johnston, Frances Benjamin, 39–40
Keys Hall, 110–112
Kiah Hall, 27, 29–37, 44, 45
Kiah, Virginia, 33
Koch, Augustus, 29
Lai Wa Hall, 114–115
Lane, Mills B., 71
Law, W. W., 84
Lawton, Alexander R., 110
Levy's Department Store, 82–84
Low, Juliette Gordon, 7, 27
Lubs, John F., 116–117
Massie School, 67
McDonald Brothers, 68
Meyers, Lee, 85
Montgomery Hall, 88
Morris Hall, 100, 105–109
Murphy, Christopher A. D., 38
National Historic Landmark District,
 8, 9
Norris Hall, 66–67
Norris, John S., 66–67
Norrman, Gottfrid, 50, 54–55, 57–58,
 71, 74
North Viaduct, 38-40
Oglethorpe House, 99
Oglethorpe, James Edward, 6, 7, 20 .
Orleans Hall, 94
Pei Ling Chan Gallery, 64, 76
Pepe Hall, 58–61
Pepe, Dr. Marie, 58
Poetter Hall, 2, 4, 8, 11–26, 106
Poetter, May L., 4
Poetter, Paul E., 4
Preston Hall, 8
Preston, William Gibbons, 7, 11–16,
 18–19, 21–22, 24
Propes Hall, 71–74
Pulaski House, 79
Red Building (see Eichberg Hall), 26,
 29, 41, 43
Rentzel, Barry, 94

Richardson, Henry Hobson, 24
St. Andrew's Independent Episcopal
 Church, 78
Savannah City Hall, 78
Savannah Female Orphan Asylum, 13
Savannah Victorian District, 8, 9, 89
Savannah Volunteer Guards Armory,
 2, 4, 7, 10, 11–26
Savannah Widow's Society, 66
Schwaab, Augustus, 31, 38
Silva, James S., 38
Scottish Rite Temple, 24, 78
Shoppell's Modern Houses, 119
Slater, James C., 91
Slotin & Co. Dry Goods, 94
Smets, Alexander Augustus, 105–108
Smithfield Cottage, 118–123
Solomon, Mrs. Celia, 103
Solomon's Drug Company, 15, 103
South Sheds (see Down Freight
 Warehouse), 28, 37–38, 42–45
Southern Terra Cotta Works of
 Atlanta, 50, 53
Streamliner Diner, 89-90
Student Center (see B'nai B'rith),
 77–78
37th Street School, 51, 62–63
Thomas Square Trolley Historic
 District, 8, 9, 62
Tomochichi Room, 20
Trustees Theater, 95–98
Tucker, McKendree, 95, 98
Wadley, William M., 29, 30
Wallin Hall, 62-63
Wallin, Henrik, 62
Weis Theater, 95–98
Williams, Jesse Parker, 118–119
Witcover, Hyman Wallace, 54, 77–78
Wood, J. A., 14
WTOC, 111–112
Up Freight Warehouse (North
 Sheds), 31, 37, 41
Young, Edwin, 62
Young, H.O., 44